CINDY GUENTERT-BALDO

The ultimate DOODLE Collection

Collection

for JOURNALS, Planners, and more

CINDY GUENTERT-BALDO

The Ultimate
DOODLE
Collection
for
JOURNALS,
Planners,
and more

THUNDER BAY
P · R · E · S · S
San Diego, California

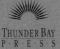

Thunder Bay Press

An imprint of Printers Row Publishing Group
A division of Readerlink Distribution Services, LLC
9717 Pacific Heights Blvd. San Diego, CA 92121
www.thunderbaybooks.com • mail@thunderbaybooks.com

Correspondence regarding the content of this book should be sent to
Thunder Bay Press, Editorial Department, at the above address. Author
and rights inquiries should be addressed to Quarto Publishing plc, at the
below address.

For Thunder Bay Press
Publisher: Peter Norton • Associate Publisher: Ana Parker
Editor: Dan Mansfield
Acquisitions Editor: Kathryn C. Dalby

Conceived, edited, and designed by Quarto Publishing plc
an imprint of the Quarto Group
The Old Brewery
6 Blundell Street
London N7 9BH
www.quartoknows.com

Quar: 338368

For Quarto
Editor: Claire Waite Brown
Art Director: Gemma Wilson
Designer: Karin Skånberg
Publisher: Samantha Warrington

ISBN: 978-1-64517-637-4

Printed and bound in Singapore

25 24 23 22 21 1 2 3 4 5

MIX
Paper from
responsible sources
FSC™ C007207

Contents

Meet Cindy

I've been drawing, painting, and hand lettering for most of my life. It's been a hobby for as long as I can remember, and I started doing it professionally nearly 15 years ago. For many years I worked in a food store creating shelf signs and big display artwork, but in 2016 I started working for myself.

I've also used paper planners for as long as I can remember. Even before I started living the decorative-planner life, I would use different colored pens to take notes and generally make my daily plans bright and cheerful. There is nothing like a rainbow of colors to make a boring day of laundry look fun!

In 2013 I discovered the online planner community and the world of planner stickers. At the time, I was having a lot of trouble making creative time for myself at home, since I had two small children and spent almost all of my creative energy at work each day drawing avocados with smiley faces and hand lettering the word "organic." It was difficult to justify spending any time making creative work just for me, even if I so desperately needed that time for myself.

Finding the planner community changed all of that. I was able to be productive and creative at the same time! And because I had so much fun decorating my planner, it encouraged me to use my planner every day, which made my life run more smoothly. At the time, there weren't a lot of people posting pictures of hand lettering or doodles in their planners on social media, so when I started showing what I did, people began asking me to teach *them* how to do it. That's when I started my YouTube channel.

Now, over 1,000 videos later, I've traveled all over the United States showing people how to make their planners cute. I love showing people that even with no experience, they can doodle and make their planners and journals both personalized and functional for them! Most importantly, I'm surrounded by a community of people who are trying to fit creativity into their lives however they can, while maintaining a sense of humor along the way.

The planners are how we found each other, but the friendships are why we stay.

About This Book

Work through the easy-to-follow instructions and try out what you learn on the practice pages, and you'll soon be doodling like a pro.

CHAPTER 1: GETTING STARTED

This chapter is here to assure you that great doodling is not as unattainable as you might think. It will introduce you to materials, basic drawing terminology, and the importance of practice.

PAGES 12-29

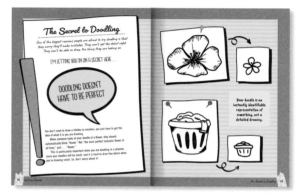

CHAPTER 2: DOODLE BASICS

This chapter focuses on basic doodles to use in the structure of your daily journaling and planning. They are built from simple shapes, so they are the easiest to doodle.

PAGES 30-43

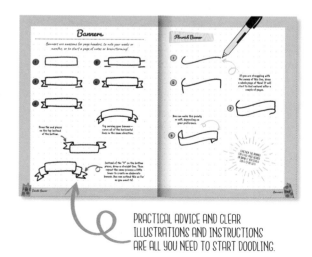

PRACTICAL ADVICE AND CLEAR ILLUSTRATIONS AND INSTRUCTIONS ARE ALL YOU NEED TO START DOODLING.

CHAPTERS 3-7: DOODLES

I have organized the doodles into handy chapters covering aspects of life that you are likely to want to use in your journal or planner, from activities to foods to seasons and transportation.

PAGES 44-231

PRACTICE IN PENCIL OR PEN. HOWEVER, A GRAY LINE INDICATES THAT YOU WILL NEED TO ERASE IT LATER, SO YOU SHOULD MAKE THIS MARK IN PENCIL.

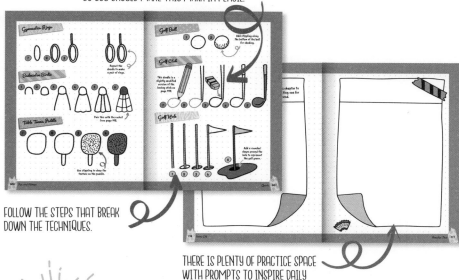

FOLLOW THE STEPS THAT BREAK DOWN THE TECHNIQUES.

THERE IS PLENTY OF PRACTICE SPACE WITH PROMPTS TO INSPIRE DAILY DOODLING AND EXPERIMENTATION.

PAGES 232-239

CHAPTER 8: NOW WHAT?

The final chapter features encouragement and ideas on how to move forward, including ways to use your newfound doodling expertise.

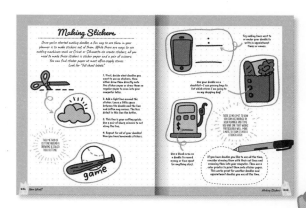

All the Doodles

The doodles are organized by chapter, but for those times when you want to find a particular doodle, use this handy list.

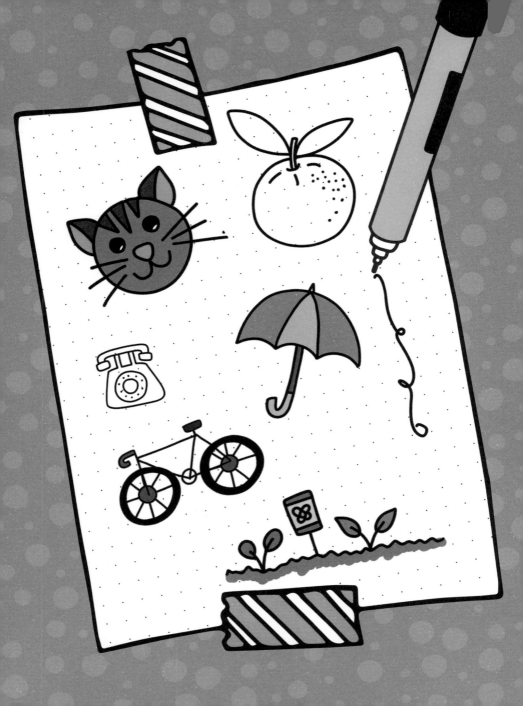

CHAPTER 1

Getting Started

Gathering the confidence to pick up that pen and start
drawing is the hardest part, and often this is when so many
people give up. You aren't going to do that.

You're going to at least read this chapter, where I talk
all about confidence, why you should do this in the first place,
shopping—the best part—and more.

I'll see you on the other side.

The Secret to Doodling

One of the biggest reasons people are afraid to try doodling is that they worry they'll make mistakes. They won't get the detail right. They won't be able to draw the thing they are looking at.

I'M LETTING YOU IN ON A SECRET HERE . . .

DOODLING DOESN'T HAVE TO BE PERFECT

You don't need to draw a lifelike re-creation; you just have to get the idea of what it is you are drawing.

When someone looks at your doodle of a flower, they should automatically think "flower." Not "the most perfect fantastic flower of all time," just . . . "flower."

This is particularly important when you are doodling in a planner, since your doodles will be small, and it is hard to draw fine detail when you're drawing small. So, don't worry about it!

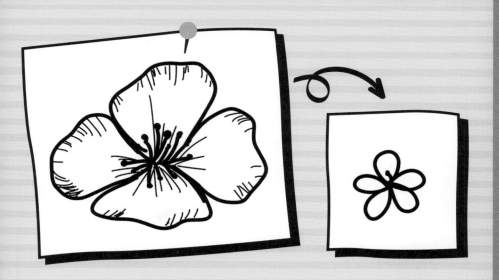

Your doodle is an instantly identifiable representation of something, not a detailed drawing.

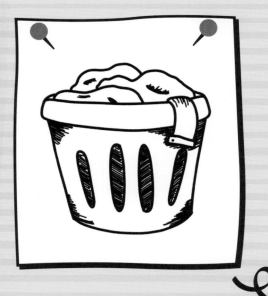

WHY Doodle
IN YOUR PLANNER?

It's no secret that I love creative planning and journaling. I mean, I've already written a book about how to use hand lettering in a planner!

And I love using stickers to dress up my planner in an aesthetic way and for productivity.

SEE PAGES 234-235

But why doodles?

✓ Aesthetics

Doodles are cute! And by drawing them yourself, you can decide exactly how you want your planner or journal spread to look, from the style to the choices of doodles themselves, and how you color them.

✓ It's FUN!

Drawing and doodling is fun. And the more you do it, the more fun it gets!

Productivity

Using your planner effectively can increase how productive you are. Using doodles to help you pay attention to different appointments or activities (such as when you need to set up the slow cooker or go to the pharmacy) can keep you on task and on time.

Cost-effective

If you love using icon stickers in your planner, you can save money by drawing the icons yourself. And as a bonus, you'll always have the exact icon you need.

It's Good for You

Studies have shown that you can boost both thinking skills and memory by drawing—what better way to achieve this daily than to do it in your planner?

Pens

The best doodling pen is . . . the pen you are comfortable using. Not that exciting, eh? It's true, though. It is more important to have a pen you like and are happy using than to have the greatest fineliner in the world.

Don't let buying pens keep you from starting—start, then add pens to your collection as you learn! Here's my rundown of the types of doodle-friendly pens you will come across.

FINELINERS

My favorite type of pen for doodling, fineliners have either a porous or plastic tip and are used for all sorts of drawing, by hobbyists and professionals. If you are heavy-handed (as I am), the tips can wear down quickly. My personal favorite fineliners are Papermate Flairs for practice and Pigma Microns for finished work and in my bullet journal.

GEL PENS

These super-comfortable writing pens don't lose their tip. Gel pens are my favorite pens for writing in my planner, and they are great for doodling there as well. My favorite gel pens for writing are Pilot G2 pens and Sakura Dry pens—these are also great for color, but more on that later!

BALLPOINT PENS

A great affordable option, you can buy these pens in a big pack when you are just starting out. They can skip, so be wary of that. A great sketching pen for a loose and sloppy look. I love the Bic Crystal pens.

Fineliner

Gel pen

Ballpoint pen

Common to the types of pens are their tip sizes and type of ink. So, here are my tips on tips!

Permanent ink pens to avoid smears

TIP SIZES FOR FINELINERS AND GEL PENS

Most fineliner and gel pens come in an array of sizes, from ultra-fine (around 0.2 mm) to extra bold! For practice, I prefer a bolder pen, because the thick tip can help camouflage shakiness. For finished work and when I want to add a little detail, I prefer to have two pens, a bolder tip (around 0.5 mm) for most linework and a finer tip (around 0.3 mm) for shading. You can often pick up a pack of fineliners with an assortment of tips (Pigma Micron and Pitt Artist Pens both have great kits).

INK

If you plan to add color or use highlighters with your doodles, and want to avoid smearing, look for the words "waterproof" or "archival ink" on your pens. These inks are permanent and will not smear if you add a water-based color on top of them. That said, the smeary look is really beautiful in some circumstances, so don't rule out water-based pens entirely!

Fineliners: ultra-fine to bold

Adding Color

While I love a good black-and-white doodle, part of the fun of drawing in your planner is adding color to it. I use these pens to introduce color, but this is not an exhaustive list—rather, it is a little something to get you started!

MARKERS

For a smooth color application, consider using colorful markers. You can find them in a range of prices from super cheap to super pricey. They are available in every color you can think of and, to be honest, coloring with them is fun. The biggest drawback to using markers in your planner is the bleed through, so be sure to test them first. My favorite markers are Tombow Dual Brush Markers, while my favorite inexpensive option is Crayola Supertips. Both markers are available in tons of colors, and both work great!

COLORED PENCILS

Colored pencils do not lay color down as smoothly as markers, but they also don't bleed. You can generally blend colors together, find wide assortments of different types of colored pencils—even watercolor ones—and you can get decent quality ones for a great price. I love the Crayola set for an inexpensive version, and the Prismacolor softcore pencils for a pricier choice.

Markers

Colored pencils

HIGHLIGHTERS

Much like markers, highlighters are great for smooth color application, and you can find them in a range of pastel colors as well as the traditional bright fluorescents. They tend to bleed a little less than standard markers, but do not generally come in darker or opaque colors. I love the Zebra Mildliners for both color range and their dual-sided tips.

Keep a white ink pen on hand for adding highlights and correcting mistakes. My favorite is the Uniball Signo Broad White gel pen. A good alternative is the Gelly Roll White pen in 0.8 mm.

COLORFUL FINELINERS AND GEL PENS

Remember those pens we talked about on page 18? You can often get them in colors as well! Some sets come with a ton of colors, some just a few, but if you love drawing with them, you may also love coloring and color-coding with them. You won't get as smooth an application, but you gain a bunch of versatility. Gelly Roll Gel Pens come in a huge range of colors, and glitters, and neons, and so much more!

PAINTS AND INKS

Painting in your planner or journal can be risky, but high risk comes with high reward. If you want to give paints or inks a try, I'd start with watercolor, very slowly. Be sure to test your paper first, and don't use wet mediums in this book.

Gel pens

Watercolor paints

Tools and Other Supplies

To get started, all you really need is a pen (and a pencil) and this book. However, here are some fun extras that can come in handy as you learn to doodle and begin a doodling practice.

PENCILS

To begin with, you will want to use a pencil to draw your doodles—so you can erase anything you're not happy with—and a pen to go over the lines when you love what you've created. Some of your doodles will have overlapping lines that need erasing, and these are indicated in the steps. Pencils come on a scale of H (hardness) to B (blackness). I recommend a 2H or a 2B pencil for ease of erasing.

ERASERS

Use a rubber or plastic eraser to erase guidelines.

Pencils H-B

Sketchbooks

PRACTICE PAPER

This book is a great start for practicing, and you'll find plenty of space for that here. However, I recommend you pick up an inexpensive sketchbook to continue practicing—I prefer a spiral-bound sketchbook for ease of use.

PLANNERS AND JOURNALS

When choosing from the many planners and journals on the market, one thing to look at is paper weight (measured in either pounds or grams per square meter). The higher the paper weight, the thicker the paper. If you use markers and thick pens, go for a heavier paper weight!

If you don't want to draw your weekly or monthly calendars, a preprinted planner is best, but if you prefer flexibility and lots of space for creativity, go for a notebook (I love a dot grid).

Left-handed people might want to avoid spiral-bound notebooks and planners due to the binding making it difficult to write near the center of the page.

PAPER AND PENS FOR FINAL WORK

For pieces you want to last a long time, you'll need drawing paper and ink pens that are "archival" quality (and acid-free), for the longest-lasting works.

Notebook

Doodles Jargon

Throughout the book I use various terms to describe the marks I make. Some of these terms are actual art terms—crosshatching, for example—while others are more . . . descriptive! Here's a visual guide to some of the most commonly used jargon you'll find in this book.

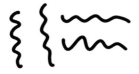

SQUIGGLY LINES
Making soft bumps in your line. You can make them even with each other or the bumps can be randomly sized.

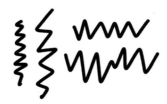

JAGGED LINES
Similar to squiggly lines, but instead of soft bumps you make hard points.

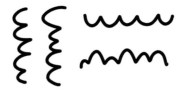

SCALLOPED LINES
Curved lines drawn in a row or a line. Think of a lowercase "u" drawn over and over again.

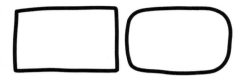

HARD VS. ROUND CORNERS

We will make use of both hard- and round-cornered shapes in this book. Corners can come to hard points, as with a standard rectangle, or be rounded into a soft corner shape.

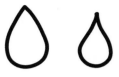

RAIN- OR TEARDROP

A tapered oval shape with a point at one end. Curving the lines inward creates a more realistic droplet shape.

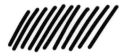

HATCHING

Parallel lines drawn next to each other. This is a great way to add texture or shading. The closer the lines are to each other, the darker the effect.

CROSSHATCHING

Two sets of parallel lines at right angles to each other—a more complex version of hatching.

DASHED LINES

Drawing short lines in a row or in a group. You can make the lines all the same size, or make some long and some short.

STIPPLING

This method of adding texture or shading uses repeated dots. The closer you place the dots to each other, the darker the effect.

PRACTICE. PRACTICE. PRACTICE!

The most important part of learning to doodle isn't the pen you use, the paper you draw on, or even the book you're teaching yourself from—gasp!

IT'S PRACTICE!

I know, it's not the coolest of concepts, but doing a little doodling every day means that every day you get a little bit better.

Throughout this book there are practice pages and prompts. Use them. And, after you've used them for a month, go back and look at them. You may not see progress after one day of practicing, but after a month? The progress will be there, and it will motivate you to keep going. Which means more practicing!

HAVE FUN WITH IT, AND BE SURE TO DO IT. I'LL BE WATCHING YOU—IS THAT CREEPY?

Fixing Mistakes

Mistakes happen. When you're learning, they happen all the time. When you're really good at doodling, they still happen all the time. In pencil it's simple—just erase away. In a pen doodle, you have a number of options.

This is the mistake. You can simply ignore it and move on—this is what I do most of the time, because I'm lazy!

OR USE ONE OF THESE COVER-UP METHODS:

Use a white gel pen to carefully color over the mistake. You can draw on top of the white gel pen—it will look a little wonky, but for tiny mistakes this works very well.

Messily draw around the doodle a few times. This will hide the mistake and give your drawing a sketchy look.

Draw neatly around the doodle with a thicker pen to hide the mistake.

Color in the area with the mistake with a black pen.

Use shading to camouflage the mistake.

TURN THE PAGE AND START AGAIN! YOU CAN ALWAYS DO THIS, NO MATTER HOW MUCH YOU GOOF.

Be Kind to Yourself

Before I send you off into this book to get started,
I have a few things I want to impress upon you.

BE KIND TO YOURSELF!

Learning anything takes time, and the last thing you need is to get mad at yourself while you're still figuring it out. Anytime you catch yourself being unkind while practicing, think of me telling you you're doing great! Because you are.

DON'T COMPARE YOURSELF TO OTHERS

You have no idea how much time or practice they've put in, and it isn't fair to you or them when you make comparisons, so don't bother. If you want to compare yourself, do what I said earlier in this chapter and compare what you're doing today against what you did a few weeks ago.

CARRY THIS BOOK EVERYWHERE AND GET PRACTICE IN WHENEVER YOU CAN

The more you practice, the better you'll get, and the better you get, the more you'll practice . . . it's a self-fulfilling prophecy.

And if you still feel bummed out, see point 1.

Plus, this book is cute, and you'll feel cute carrying it.

Make a promise to yourself to practice a certain amount each day or week, and that you'll be kind to yourself while you do it. Write that promise down here.

I promise I will:

Come back to this page whenever you find it getting hard, or whenever you start being hard on yourself.

YOU GOT THIS, MY FRIEND. NOW LET'S GET GOING!

CHAPTER 2

Doodle Basics

No matter what your everyday life looks like, there are certain basic doodles that you will use repeatedly when illustrating your plans.

Once you get the hang of the basics in this chapter, you'll have the confidence to head into the rest of the book and get your doodle on!

Basic Shapes

Some of the most useful things you can doodle in your planner are your basic shapes—experimenting with different sizes and proportions can give you endless options!

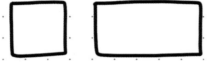

Squares and rectangles

Circles and ovals

Long, skinny rectangles make great headers.

Round out rectangle edges for a fun look!

Fun with Edges

Rather than using straight lines, experiment with different ways to draw your boxes!

Give it a try!

Checklists

Add different shapes inside boxes to create checklists.

Check out page 37
to learn how to
create this look.

Drop Shadows

Adding drop shadows to your doodles adds detail and depth.

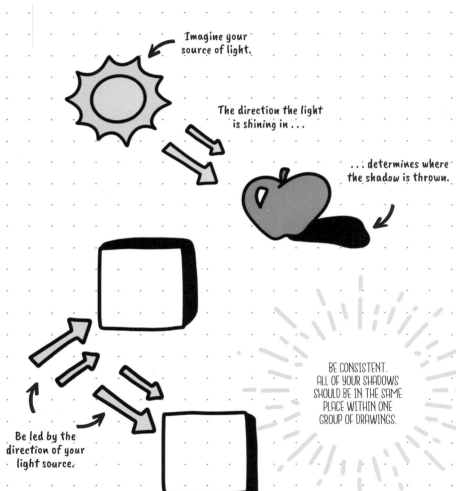

Imagine your source of light.

The direction the light is shining in . . .

. . . determines where the shadow is thrown.

Be led by the direction of your light source.

BE CONSISTENT. ALL OF YOUR SHADOWS SHOULD BE IN THE SAME PLACE WITHIN ONE GROUP OF DRAWINGS.

Experiment with different types of shadows.

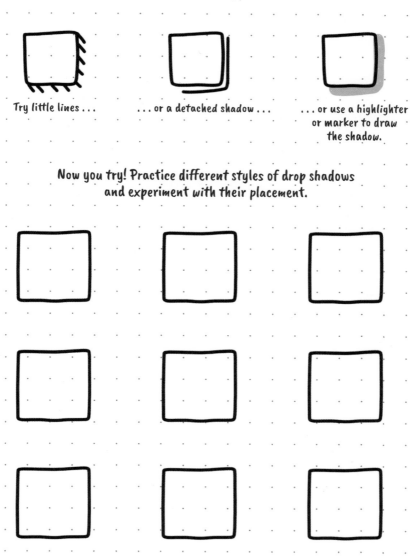

Try little lines . . .

. . . or a detached shadow . . .

. . . or use a highlighter or marker to draw the shadow.

Now you try! Practice different styles of drop shadows and experiment with their placement.

Flags

Small flags are great to use in your journal or planner to indicate meetings, appointments, and other things you want to be sure not to miss!

Flag Styles

1 **2** **3**

Change the proportions.

Add a smaller flag inside a big one.

Make it double-sided.

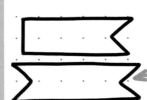

Use a circle on top of a rectangle to create a flagpole.

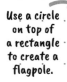

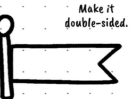

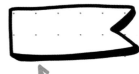

Add a drop shadow.

1

2

Use wavy lines.

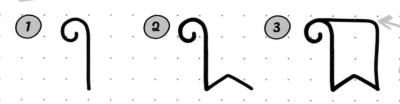

Curly Flag Over

① ② ③

Keep this corner soft.

④

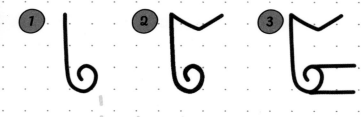

Curly Flag Under

① ② ③

④ ⑤

CHOOSE WHETHER TO CURL THE FLAG OVER OR UNDER—A BIT LIKE TOILET PAPER!

Banners

Banners are awesome for page headers, to note your weeks or months, or to start a page of notes or brainstorming!

①

②

③

④

⑤

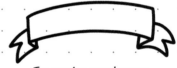

Try curving your banner—curve all of the horizontal lines in the same direction.

Draw the endpieces on the top instead of the bottom.

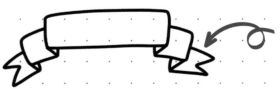

Instead of the "V" on the bottom pieces, draw a straight line. Then repeat the same process a little lower to create an elaborate banner. You can extend this as far as you want to!

Flourish Banner

1

2

If you are struggling with the swoop of this line, draw a whole page of them! It will start to feel natural after a couple of pages.

3

You can make this pointy or soft, depending on your preference.

4

LENGTHEN THE BANNER FOR A FULL-PAGE HEADER OR DRAW IT VERTICALLY FOR A TO-DO LIST!

Borders

Borders can be used to create dividers between sections on a page, as decoration around the edges of a spread, and so much more!

These simple borders are made using dots and different lines.

Try combining dots and lines in different ways.

See page 46 for some ideas on how to make a cloud line.

Doodle Borders

These borders use doodles you'll learn to draw later in the book.
This is just to inspire you, and show that you can create endless
borders using your favorite doodles.

Clouds

Flowers

Balls

Music staff and notes

Ruler

Use this space to practice your basic doodles! I suggest practicing the ones that give you the most trouble, whether it is a curly banner or drop shadows.

CHAPTER 3

Seasonal Doodles

From daily weather to the trips we take, our
environment plays a big role in our
day-to-day lives.

In this chapter, we will look at seasonal
doodles, giving you year-round inspiration to
decorate your planner, add some flair to trip
planning, and track the daily weather.

Weather

Sun doodles start with
a circle.

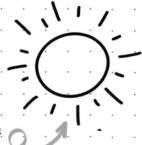

Draw alternating short
and long lines around the
circle for an easy sun.

Creating this pointy wave line
is easy—it is basically a bunch
of lowercase "w" shapes next
to each other.

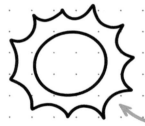

Use the pointy wave
line all around a circle
for a different style
of sun doodle.

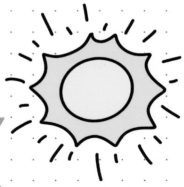

You can combine two styles of sun
doodle to create a third!

I love putting an angry
face in my sun to indicate a
really hot day!

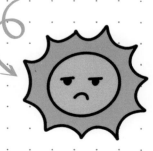

Cloudy Skies

Revisit the pointy wavy line from page 45 and turn it upside down to create a cloud line.

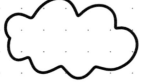

Use that line in an oval shape to create a basic cloud.

Play with small and large bumps in your cloud lines.

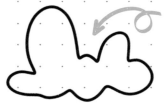

When you are making a cloud with this line, concentrate your largest bumps on the upper part of the cloud and keep the bottom smaller!

YOU WILL USE THESE LINES MANY MORE TIMES THROUGHOUT THE BOOK WHEN DRAWING OTHER NON-CLOUD DOODLES!

Overlapping Clouds

Draw a second cloud, starting and stopping at the edge of the first cloud.

1

2

Curlicue Cloud

1

Practice drawing swirls to add detail to your clouds.

2

When drawing the top of your bumpy cloud, start and end with a swirl.

3

THEN add your bottom!

Sunshine on a Cloudy Day

1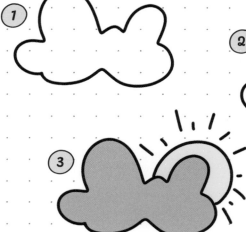

2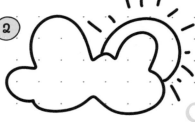

This time, replace the second cloud with a sun of your choice.

3

Raindrops

1

Start drawing your line along the curve of the circle.

2

3

4

Draw around the edges.

Use the basic principles of the steps above, and play with size and shape.

Rainy Days

Draw a cloud and add small raindrops below it.

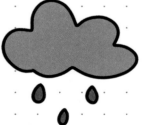

Cluster three raindrops together to indicate a very rainy day!

Draw a long, wavy-line blob with drops around it for a puddle.

Start your snowflakes with a basic plus sign.

Use lines, circles, and other shapes to create different snowflakes.

1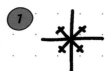

1

1

2

2

2

THE COOL THING WHEN DOODLING SNOWFLAKES IS THAT YOU CAN BE REALLY CREATIVE.

Snow Days

For smaller flakes, try using scribbly little doodles!

For a snowy slope, simply draw a wide, wavy line.

Use a cloud and those scribbly doodles together!

Lightning Strikes

1 Draw a zigzag line . . .

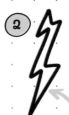

2 . . . follow the same line back up the other side.

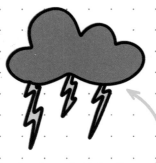

Start and end your lightning from the bottom of a cloud . . .

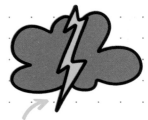

. . . or draw your lightning bolt and then draw your cloud around it!

When the Wind Blows

For wind, practice drawing a "J" on its side (facing up and down).

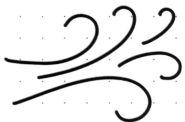

Start with two "J" lines facing outward, then add more in the middle, getting smaller and smaller!

Rainbow

1

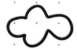

2

3

Add as many inner lines as you want! The more you add, the less you'll be able to see that color if you color in the rainbow.

You can also draw a rainbow with only one cloud, ending the lines by closing them off.

Look at the weather forecast for the next week and draw your different weather doodles. Write the temperature down next to them.

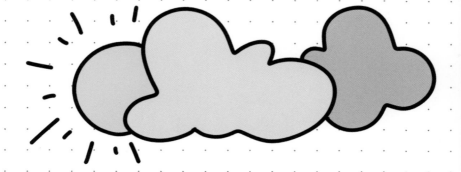

Spring

Spring Tree

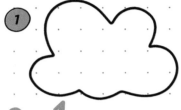

1

Start with a
cloud . . .

2

. . . and add a
trunk!

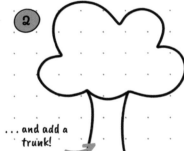

3

Add
details.

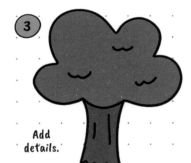

FOR LEAF
IDEAS, CHECK
OUT PAGE 71.

Clover

1 **2** **3** **4** **5**

Draw a heart then repeat.

Draw a stem, and add one of the flowers below!

Flowers

USE THESE DOODLES AS IDEAS TO CREATE FLOWERS OF YOUR OWN. EXPERIMENT WITH DIFFERENT SHAPES, SIZES, AND COMBINATIONS.

Rain Boots

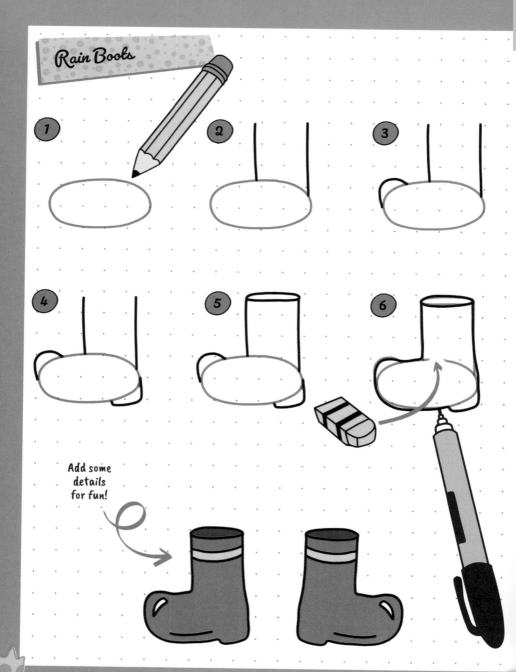

1

2

3

4

5

6

Add some details for fun!

Umbrella

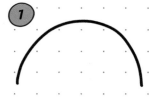

1

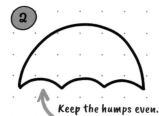

2

Keep the humps even.

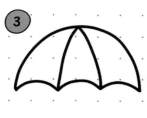

3

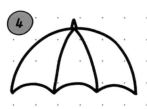

4

5

6

7

YOU CAN GIVE YOUR UMBRELLA ANY KIND OF DECORATION. ADD CIRCLES OR WAVY LINES INSTEAD OF THE STANDARD STRIPES.

Bee

Draw slightly curved
lines for antennae.

Butterfly

Play with different
sizes—just make sure
that your right and left
sides mirror each other!

Experiment with
different ideas when
filling in the wings.

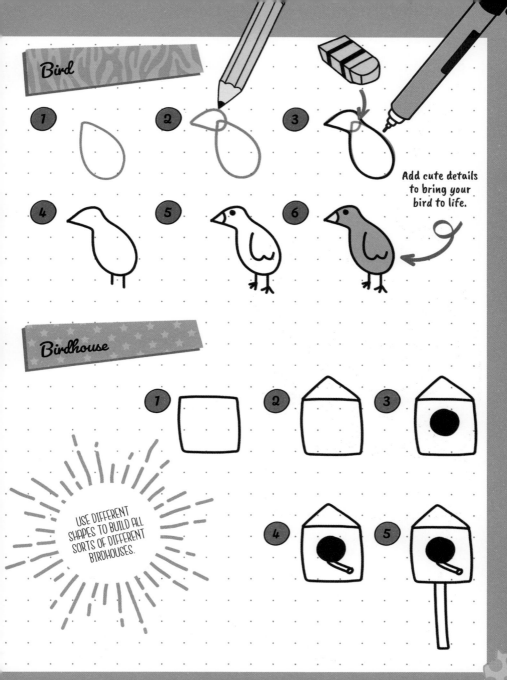

Bird

1

2

3

Add cute details to bring your bird to life.

4

5

6

Birdhouse

1

2

3

4

5

USE DIFFERENT SHAPES TO BUILD ALL SORTS OF DIFFERENT BIRDHOUSES.

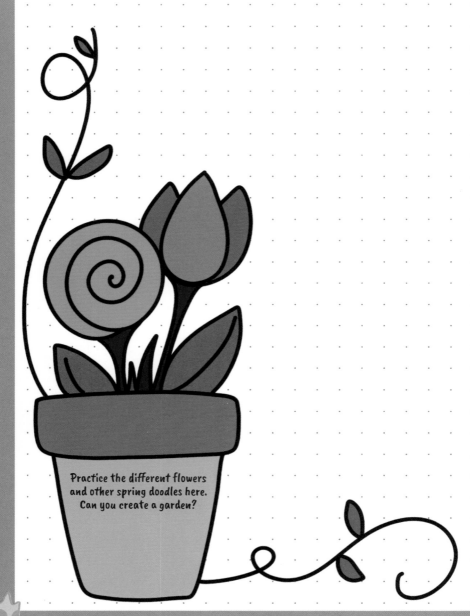

Practice the different flowers and other spring doodles here. Can you create a garden?

Summer

Beach Ball

BRIGHT COLORS FOR YOUR UMBRELLAS AND BALLS GIVE THEM A SUPER SUMMERY VIBE!

Beach Umbrella

Add a squiggly line to indicate sand.

Sunscreen

When you add the sun, we know instantly what's in this essential bottle.

Palm Tree

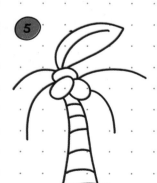 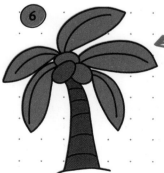

You can also use a pointy wave line for these fronds. Turn to page 79 for an example.

Sunglasses

Changing the shape of the lenses will change the shape of the glasses.

USE A WHITE GEL PEN TO DRAW LINES ON THE LENSES TO INDICATE REFLECTION.

Flip-Flops

Repeat in the opposite direction for a pair of flip-flops.

Kite

FEEL FREE TO PLAY
WITH THE INITIAL SHAPES
TO CREATE DIFFERENT
STYLES OF KITES
AND BALLOONS.

Hot-Air Balloon

Picnic Basket

 1

 2

 3

 4

 5

 6

Use loose crisscross lines to indicate basket weave.

Marshmallow Toasting

 1

 2

 3

 4

 5

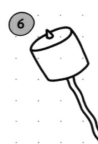 6

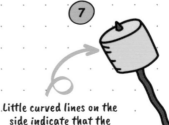 7

Little curved lines on the side indicate that the mallow's been cooked.

Campfire

1

2

3

4

5

6

7

8

9

10

11

Ants

1

2

3

4

5

You can use a line of
ants as a border for a
summer-themed spread.

Use this page to doodle
a spring scene . . .

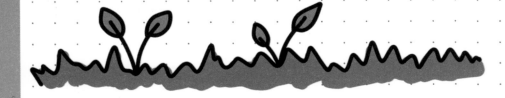

...and this page for a summer one.

Fall

Fall Tree

Draw an upside-down "V" shape to start your trunk—curve it a little for a more natural look!

FOR FALL TREES, USE ORANGES, BROWNS, AND YELLOWS. TO MAKE THIS A SPRING TREE, USE DIFFERENT SHADES OF GREEN.

Use a cloud shape to indicate leaves.

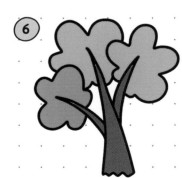

Leaves

Draw a curved line for a stem and use different shapes to create different leaves.

1 **2** **3** **4**

1 **2** **3** **4**

Acorn

1 **2**

DRAW LEAVES AND ACORNS AT THE BASE OF A TREE TO CREATE A FUN ILLUSTRATION FOR A FALL SPREAD.

3 **4** **5** **6**

Pumpkin

Change up the sizes and the number of oval sections to create different pumpkins.

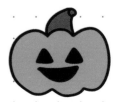

Leave out the inside lines and add simple filled-in shapes to create a jack-o'-lantern face.

Candle

1 ⬭

2

3

4

5

6

Add long, wavy lines to the candle to show that the wax has melted.

Mushroom

1

2

3

4

Add circles to the mushroom cap for a small detail.

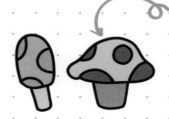

Play with size and shape.

Fall **73**

Scarecrow

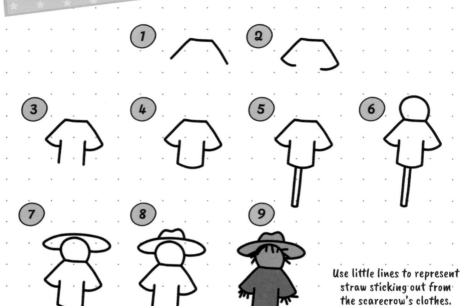

Use little lines to represent straw sticking out from the scarecrow's clothes.

Wheat

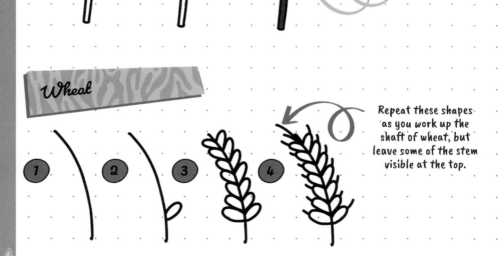

Repeat these shapes as you work up the shaft of wheat, but leave some of the stem visible at the top.

Corn

 1

 2

 3

 4

 5

 6

USE THE DOODLES ON THESE PAGES TO DECORATE YOUR SHOPPING LIST FOR A FALL FAMILY DINNER!

Apple Basket

 1

 2

 3

 4

 5

 6

 7

Use this space to practice your fall doodles, using the color palette suggested on page 70.

Winter

Snowy Tree

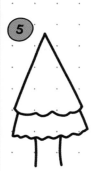

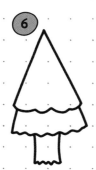

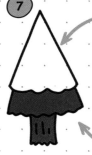

Leave the top part white and color the bottom part dark green to represent a snow-covered tree, or color both parts green to make a basic pine tree.

Icicles

Start with a straight line, or just use the top of the page!

Holly

1

2

3

4

Use the same pointy wave line from page 45 to create the leaf.

5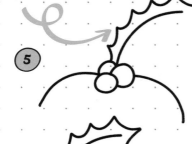

6

7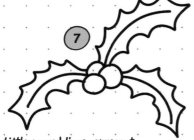

Little curved lines represent the light reflecting off the shiny berries.

8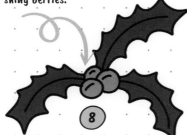

A GREAT WINTER COLOR PALETTE INCLUDES DARK GREEN, BRIGHT RED, AND A BUNCH OF DIFFERENT BLUES, ESPECIALLY DIFFERENT LIGHT BLUES!

Mittens

1

Start with a little cloud!

2

3

Repeat in the opposite direction to create a pair of mittens.

Scarf

1

Draw an oval and then continue drawing the line downward.

2

3

Follow the curve of the downward line.

4

5

6

Angle this stripe to act as a transition between the vertical and horizontal stripes.

Winter Hat

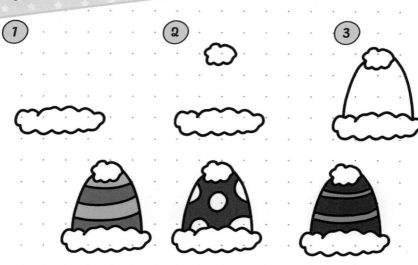

Play with stripes and circles to decorate your hat.

Earmuffs

Start with a little
vertical cloud . . .

. . . and double it.

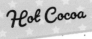

Hot Cocoa

This is whipped cream! If you don't want whipped cream, start with an oval and then go straight to step 5.

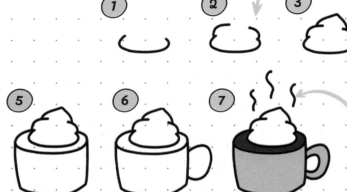

The wavy lines represent steam. This drink is so warming and comforting.

Sled

Begin with a sideways "J" (check out page 50 for an example).

Repeat the previous steps, but extend the sideways "J" out and flatten the curve a little.

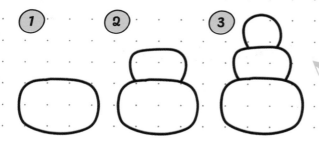

Snowman

This is your basic snowman structure, which you can use as a base to create all sorts of snow people!

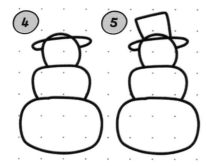

YOU DON'T HAVE TO LIVE IN A SNOWY CLIMATE TO DECORATE YOUR JOURNAL WITH SNOW. I LIVE IN CALIFORNIA AND I LOVE DRAWING SNOWMEN!

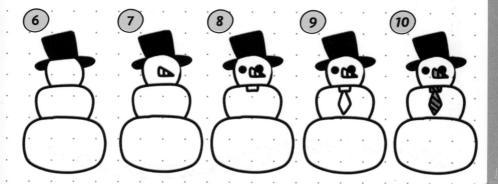

Use this space to create a monthly calendar. Decorate it for the season you are in or the season of your choice—or all of the seasons!

CHAPTER 4

Home Life

Our homes are a major part of our lives. Whether we live in an apartment, an RV, or a big house in the suburbs, our chores around the house are often a major part of our weekly to-do list.

In this chapter, we will be working on doodles that represent some of the work we do around the house—they will come in handy when you are scheduling your laundry or the day you mow the lawn—or the day you pay bills . . . yay!

Cleaning

Basic Handle

1 **2** **3** **4**

Use this versatile handle for brooms, mops, and other floor-cleaning tools.

Broom

1 **2** **3**

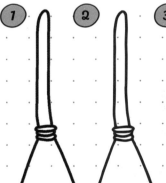 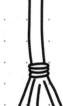

The little lines represent bristles.

Draw a shape similar to a raindrop.

Mop

1 **2** **3**

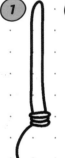

Add some little raindrops for water.

Pail

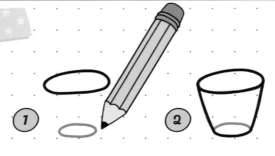

1 **2**

3 **4**

DRAW A
BIG BOX CHECKLIST
AND DECORATE IT WITH
CLEANING SUPPLIES
TO MAKE YOUR
CHORES LIST!

Sponge

1 **2**

3 **4**

*Color this bottom
area green and
the rest yellow.*

Use a raindrop shape for the body of the bottle.

Soap

This soap works well for both housework and self-care!

Laundry Basket

1

2

3

4

You can stop at step 4, or use wavy lines to represent dirty clothes.

5

THESE DOODLES NOT ONLY WORK WELL FOR LAUNDRY DAY, BUT ALSO FOR CLEANING OUT YOUR CLOSET OR DONATING CLOTHES.

Washing Machine

Swap the circle for a square to doodle a clothes dryer.

Clothesline

If you were going to clean your home today, what would you do? Doodle that. And if you hate cleaning, pretend the world's cleanest person is coming over!

Yardwork

Seed Packet

Use whatever flower you want on the front!

 1

 2

 3

Add a zigzag corner and some little scribbly doodles for extra detail.

Seedlings

Use a slightly curved "V" for the stem.

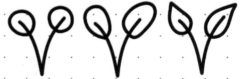

Try different shapes at the ends of the "V" to create little seedlings!

A wobbly line represents ground or grass. Use both seedlings and seed packets to decorate a gardening page.

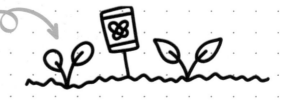

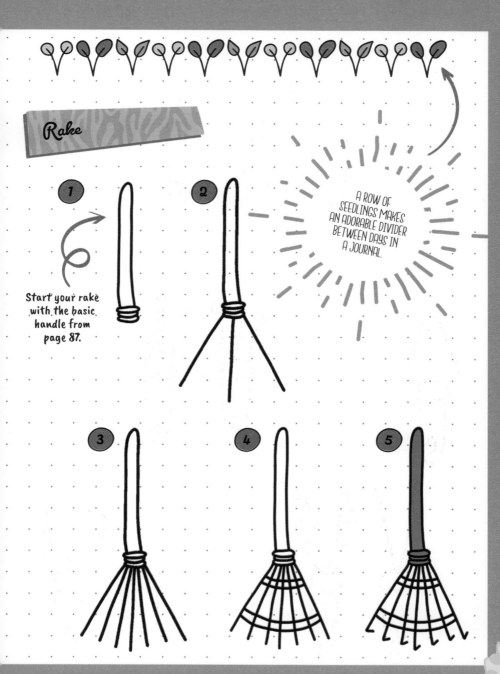

Rake

1

Start your rake with the basic handle from page 87.

2

A ROW OF SEEDLINGS MAKES AN ADORABLE DIVIDER BETWEEN DAYS IN A JOURNAL.

3

4

5

Small Basic Handle

 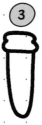

This little shape is very handy for doodling handheld tools.

Handheld Gardening Tools

Add a triangle and little lines to draw a trowel.

For a fork, add lines with hooks at the end, like the rake on page 95.

Add two little lines and a simple square and—hey presto!—you've drawn a shovel.

For pruning shears, add curved lines to a "V."

Lawn Mower

Add a jagged line in front and then a straight line behind to represent the messy, uncut grass and the smoothly cut lawn.

Trash Can

USE A TRASH CAN DOODLE TO REMIND YOURSELF TO BRING YOUR CANS TO THE CURB—ESPECIALLY IF YOU ARE FORGETFUL LIKE I AM!

Finances

Bills

Add the appropriate currency symbol for where you live.

Add some additional layers for multiple bills!

Stack of Cash

THESE DOODLES ARE GREAT FOR PAYDAYS, GOING TO THE BANK, OR GETTING COINS IF YOU HAVE TO GO TO THE LAUNDROMAT.

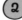
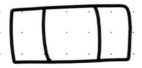

Adding this edge is similar
to adding a drop shadow
(see pages 34–35).

Coin Roll

Add currency symbols
and some details.

Here are some common
currency symbols. If
you need to get money
transferred for foreign
travel, these might
come in handy.

Money Bag

Start with a raindrop (see page 48).

1

2

3

4

5

ENVELOPE DOODLES CAN BE USED FOR MORE THAN JUST BILLS. FOR EXAMPLE GOING TO THE POST OFFICE. SENDING EMAILS. AND MORE!

Envelope

1

2

3

4

5

Change up the symbol in the circle based on what you are using the envelope for!

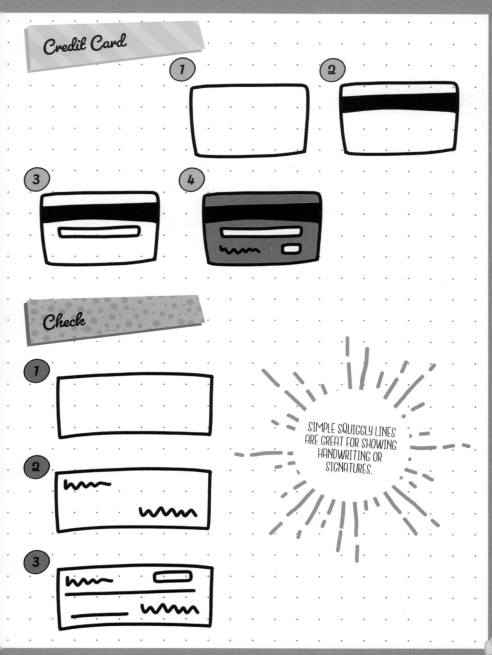

Credit Card

1

2

3

4

Check

1

2

3

SIMPLE SQUIGGLY LINES ARE GREAT FOR SHOWING HANDWRITING OR SIGNATURES.

Cooking

Cooking Pot

Omit the lid and add some squiggly lines for steam.

IF YOU USE THIS DOODLE TO REMIND YOURSELF TO SET UP A SLOW COOKER. WRITE THE TIME YOU NEED TO SET IT UP ON THE LOWER PART OF THE POT!

Cooking Pan

Kitchen Basic Handle

Here's another versatile handle doodle that can be turned into a variety of kitchen utensils.

Kitchen Utensils

Add a circle and a reflection line for a spoon.

For a whisk, add an oval and two gently curved lines.

To draw a spatula, simply add a rectangle and three short, straight lines.

For a knife, start with a shorter handle.

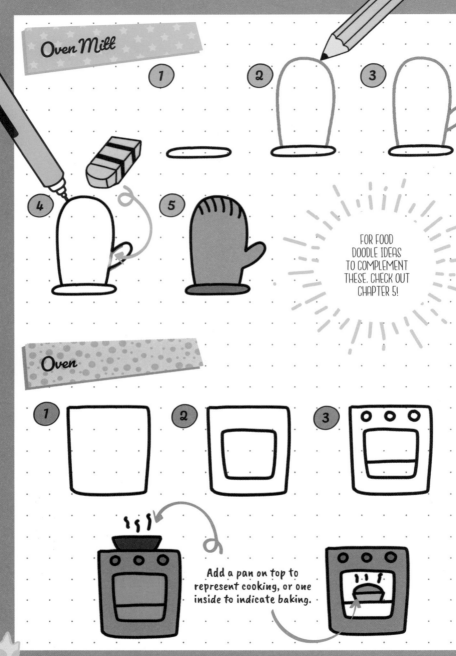

Oven Mitt

1 2 3

4 5

FOR FOOD DOODLE IDEAS TO COMPLEMENT THESE. CHECK OUT CHAPTER 5!

Oven

1 2 3

Add a pan on top to represent cooking, or one inside to indicate baking.

Measuring Cup

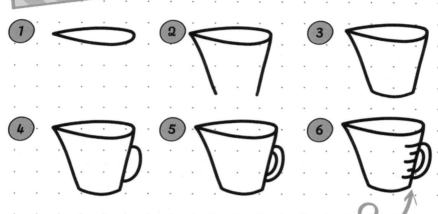

Use alternating long and short lines to represent measurements.

Flour

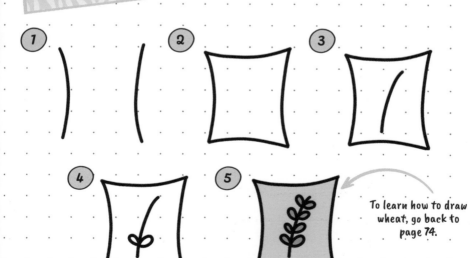

To learn how to draw wheat, go back to page 74.

Mixing Bowl

 1

 2

3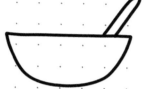

4

Rolling Pin

 1

2

3

TRY USING
A SUPER-LONG ROLLING
PIN AS A HEADER ON
A PAGE OF BAKING
IDEAS!

Muffin Tin

This doodle is two for the price of one!
To represent eggs, omit the squiggly lines
and make the top humps more oval.

Cookie Pan

Play with color and
details to represent
different cookies.

Think about the meals you cook (or eat/take out) in a week and practice using the cooking doodles to show how you'd represent those meals in your planner.

Pets

Cat

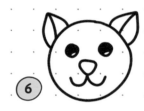

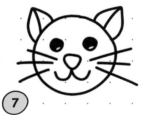

Play with stripes and spots to represent your cat.

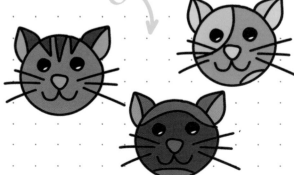

Litter Box

1

2

3

4

5

6

For the little poo, use the same style as the whipped cream on the hot cocoa on page 82.

Cat's Paw

1

2

PAWS MAKE A GREAT VETERINARIAN REMINDER (AND ARE SUPER CUTE)!

3

4

5

Dog

 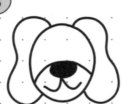

Personalize your dog by adding spots, fur, or even different ears—these are borrowed from the cat page!

Doghouse

1

2

Rather than coloring in
the door, doodle a dog
face inside instead.

3

4

5

6

Dog Food

1

2

3

4

THIS DOODLE
ALSO WORKS
FOR CAT FOOD.

Fishbowl

1

2

3

4

5

6

Add some squiggly blobs for coral, or add whatever decorations you like to the fishbowl!

Fish Food

1

2

3

4

5

Use this doodle as a reminder to feed the fish or buy more fish food.

Hamster Cage

1

2

3

REPLACE THE
WHEEL AND HAMSTER
DOODLES WITH A BIRD
DOODLE (SEE PAGE 59)
TO SUIT YOUR
ANIMAL NEEDS!

4

5

6

Snake

1

2

3

4

5

Draw a pattern that
represents your own
pet snake.

Use checklists and the doodles from this chapter to create to-do lists for yourself. Try creating one for your week and one for your weekend.

CHAPTER 5

Food and Drink

From family dinners, to the lunch you take to work,
to weekend meal prep, food and drink shows up in our plans
every single week. In this chapter, we will learn how
to doodle some of the foods and drinks
we might consume each week.

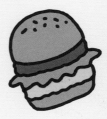

Fruits

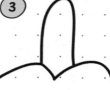

Follow the curve of the peel . . .

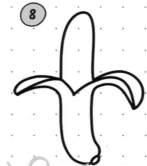

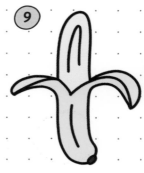

. . . then add an oval for the base of the fruit.

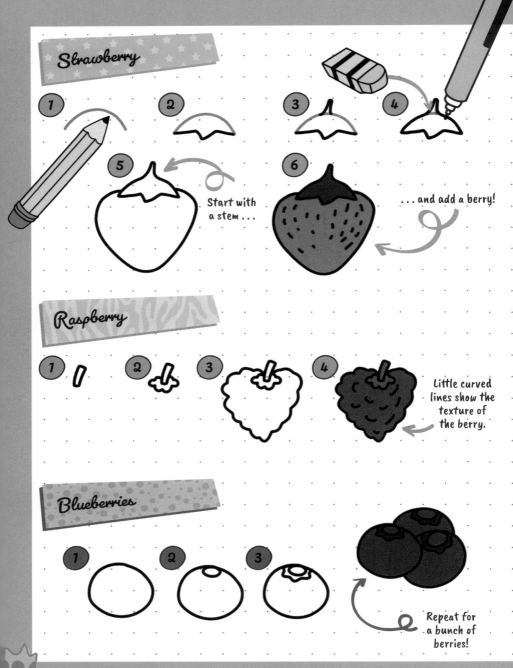

Strawberry

1
2
3
4
5

Start with
a stem . . .

6

. . . and add a berry!

Raspberry

1
2
3
4

Little curved
lines show the
texture of
the berry.

Blueberries

1
2
3

Repeat for
a bunch of
berries!

Blackberry

 1

 2

 3

Alternate rounded shapes...

 4

...then add more behind them.

 5

 6

Continue the process until the berry is as big as you'd like.

 7

Grapes

 1

2

3

 4

 5

Drawing grapes is similar to drawing blackberries!

Lemon

1

2

3

4

Use dots to show the
surface texture of
any citrus fruit skin.

Clementine

1

2

3

This doodle can be
used as a base for
many fruits!

4

5

6

Orange

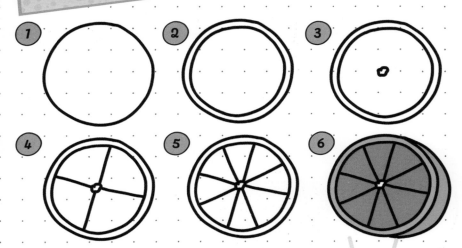

Lime

THESE DOODLES CAN BE USED FOR ANY CITRUS FRUIT. JUST CHANGE THE COLORS TO CHANGE THE FRUIT— YELLOW = LEMON; GREEN = LIME; PINK = GRAPEFRUIT; ORANGE = ORANGE!

Apple

MAKE YOUR APPLE DOODLE TALLER FOR A RED DELICIOUS. OR WIDER AND ROUNDER FOR A HONEYCRISP!

Peach

If you want a leaf, add it during this step.

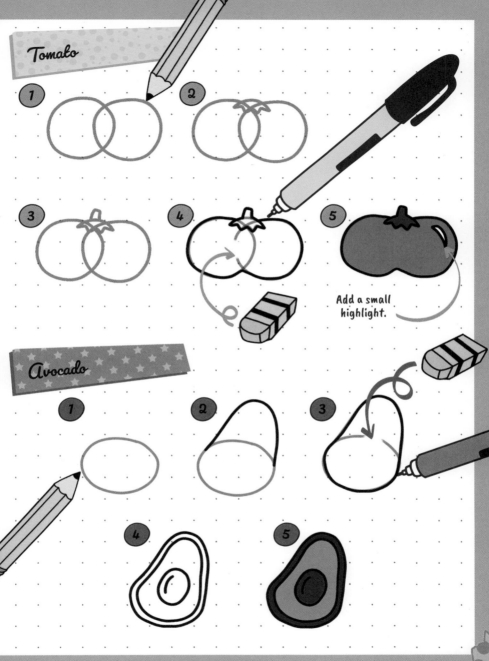

Tomato

1

2

3

4

5

Add a small highlight.

Avocado

1

2

3

4

5

Fill these pages up with fruits. Try to use every bit of available space!

Vegetables

Carrot

Use little curved lines to show the texture.

For the carrot top, use a cloud shape (see page 46).

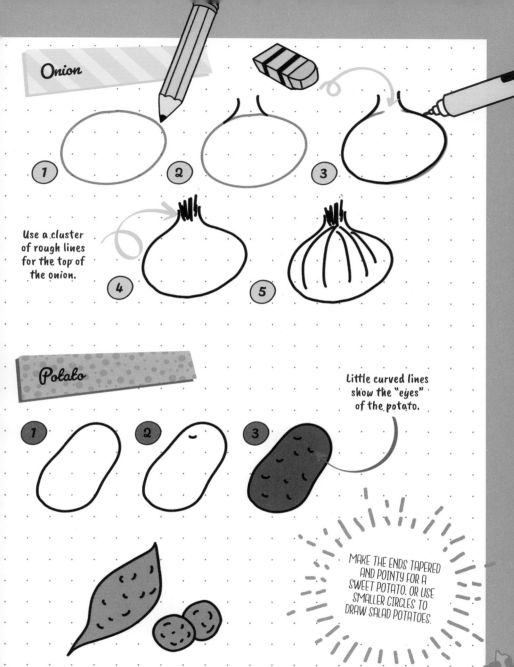

Onion

1 **2** **3**

Use a cluster of rough lines for the top of the onion.

4 **5**

Potato

Little curved lines show the "eyes" of the potato.

1 **2** **3**

MAKE THE ENDS TAPERED AND POINTY FOR A SWEET POTATO. OR USE SMALLER CIRCLES TO DRAW SALAD POTATOES.

Broccoli

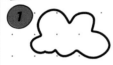 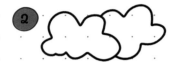 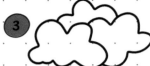

Layered clouds (see page 46) make up the top of the broccoli.

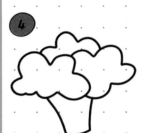

COLOR THE STALK BROWN TO MAKE A CUTE TREE.

Squash

 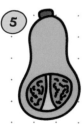

Stop here if you are drawing an uncut squash.

Celery

Bring the lines closer to each other as you draw away from the initial doodle.

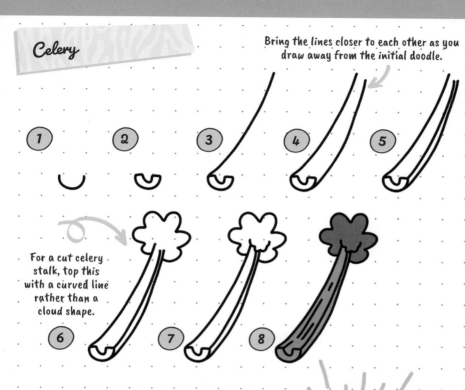

For a cut celery stalk, top this with a curved line rather than a cloud shape.

Cucumber

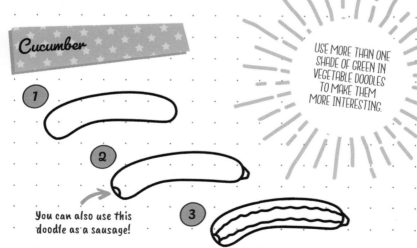

USE MORE THAN ONE SHADE OF GREEN IN VEGETABLE DOODLES TO MAKE THEM MORE INTERESTING.

You can also use this doodle as a sausage!

Green Beans

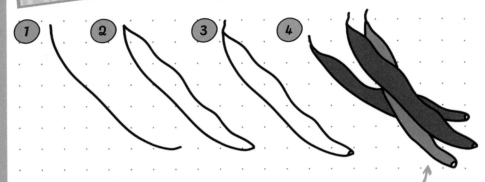

1 2 3 4

Repeat as many times as you want.

Lettuce

The more wobbly these lines are, the more natural the lettuce looks.

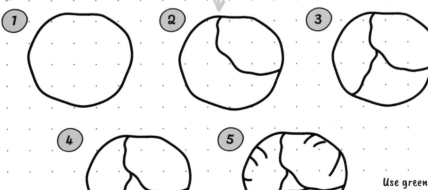

1 2 3

4 5

Use greens for lettuce or purples for cabbage!

1

2

3

4

5

This also works as a pumpkin!

COLOR YOUR PEPPER RED, YELLOW, OR GREEN. WHICH DO YOU LIKE BEST?

Garlic

1

2

Start with a raindrop shape (see page 48) . . .

. . . and then add more on each side!

3

4

5

6

Draw the fruits and veggies you love

(or can at least tolerate)!

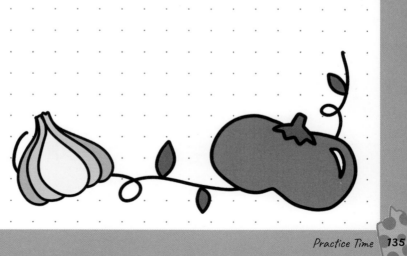

Staples

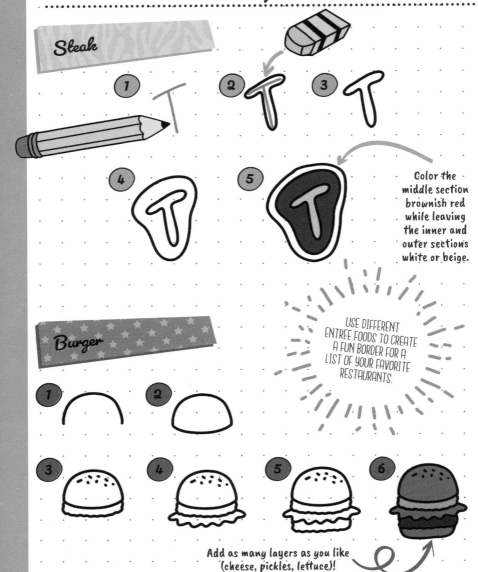

Steak

1
2
3

4
5

Color the middle section brownish red while leaving the inner and outer sections white or beige.

USE DIFFERENT ENTREE FOODS TO CREATE A FUN BORDER FOR A LIST OF YOUR FAVORITE RESTAURANTS.

Burger

1
2

3
4
5
6

Add as many layers as you like (cheese, pickles, lettuce)!

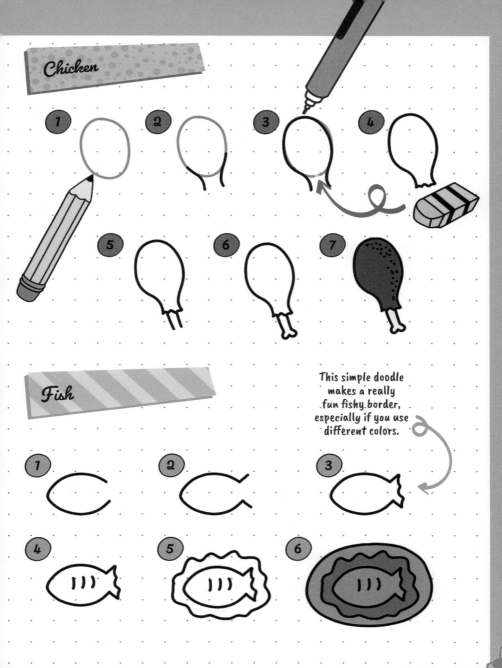

Chicken

1
2
3
4
5
6
7

Fish

This simple doodle makes a really fun fishy border, especially if you use different colors.

1
2
3
4
5
6

Bread

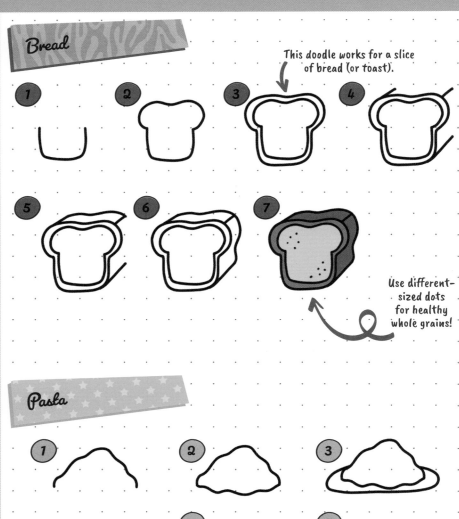

This doodle works for a slice of bread (or toast).

1 2 3 4

5 6 7

Use different-sized dots for healthy whole grains!

Pasta

1 2 3

4 5

Stop here for mashed potatoes and gravy—a fun fact: this is my favorite food!

Sandwich

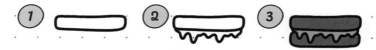

Try adding the same layers as the burger (see page 136) for a thicker sandwich.

Boxed Food

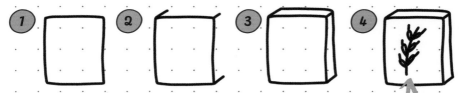

Use a shaft of wheat (see page 74) or other food doodle to indicate what's in the box!

Canned Food

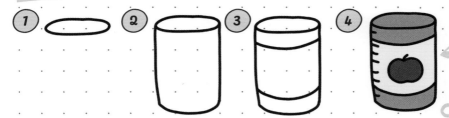

We will use this shape again later in the chapter!

Some ideas for your canned food include a tomato for sauce and a peach for canned fruit.

Butter

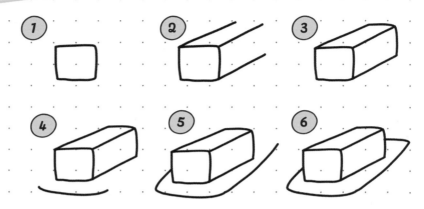

Cheese

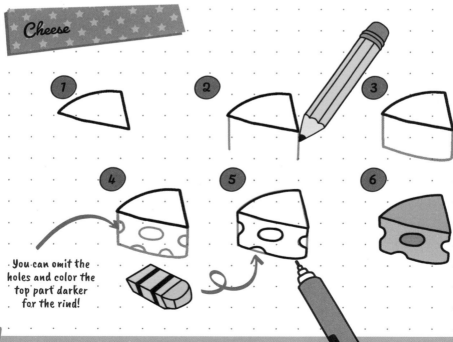

You can omit the holes and color the top part darker for the rind!

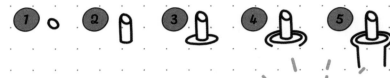

Cooking Oil

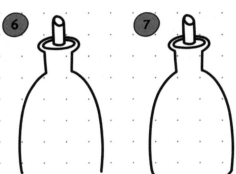

ADD LITTLE DASHES AND CURVED LINES FOR SALAD DRESSING!

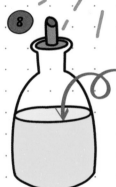

Use a flat oval for the top of the oil!

Salt and Pepper

Use fewer dots for pepper, more for salt.

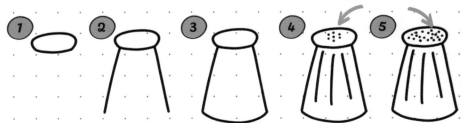

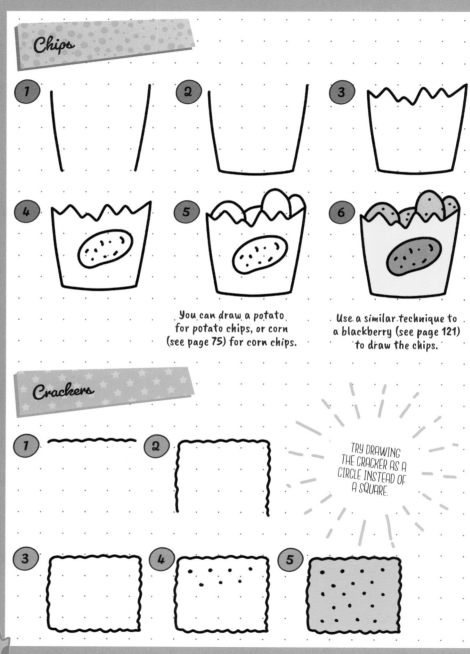

Chips

1

2

3

4

5

6

You can draw a potato for potato chips, or corn (see page 75) for corn chips.

Use a similar technique to a blackberry (see page 121) to draw the chips.

Crackers

1

2

TRY DRAWING THE CRACKER AS A CIRCLE INSTEAD OF A SQUARE.

3

4

5

Legumes

Walnut

Peanut

Cashew

Almond

Bean

What is in your pantry?
Doodle everything you can.

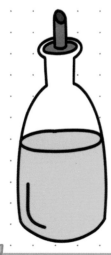

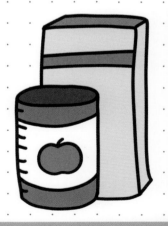

Drinks

Glass

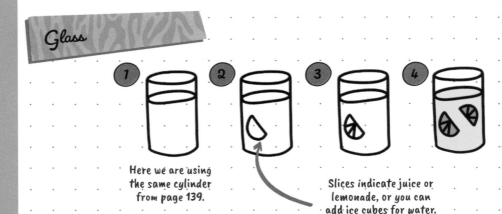

Here we are using the same cylinder from page 139.

Slices indicate juice or lemonade, or you can add ice cubes for water.

Canned Drinks

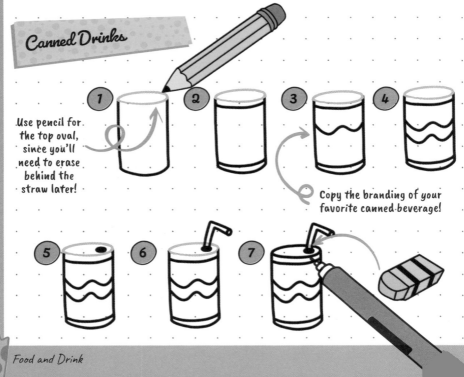

Use pencil for the top oval, since you'll need to erase behind the straw later!

Copy the branding of your favorite canned beverage!

Pitcher

Swap the ice cubes for some citrus slices.

Tea Bag

1 **2** **3**

4

Stop here and you can use this doodle as a tag for items for sale!

5 **6**

Teacup

1 **2** **3** **4**

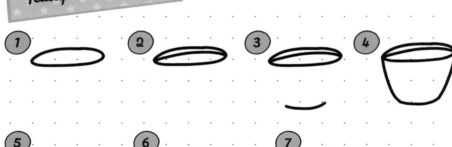

5 **6** **7**

If you prefer coffee, stop here.

To-Go Cup

1
2
3
4
5
6
7
8
9
10

Lines could indicate regular coffee, but pumpkins equal my favorite fall drink!

THIS CUP MAKES A FANTASTIC DOODLE FOR COFFEE DATES WITH YOUR FRIENDS OR BY YOURSELF—NOTHING WRONG WITH THAT!

Milk Carton

THIS DOODLE IS GREAT FOR MILK, HEAVY CREAM, HALF-AND-HALF, OR EVEN FRUIT JUICE.

Bottle

Use a raindrop (see page 48) to indicate water! Or use a fruit for flavored drinks.

Milkshake

1

2

This doodle is great for ice-cream sundaes as well!

3

4

5

6

Draw wavy lines dripping downward for a sloppy look.

7

8

I CONSIDER MILKSHAKES DRINKS RATHER THAN DESSERTS. YOU'RE WELCOME!

Beer

 1

 2

Use cloud lines . . .

 3

. . . and bring them downward
to show spillover.

 4

 5

 6

 7

 8

IF YOU DON'T
DRINK ALCOHOL, THIS
ALSO WORKS FOR A
ROOT BEER FLOAT!

 9

 10

 11

Wine

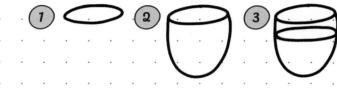

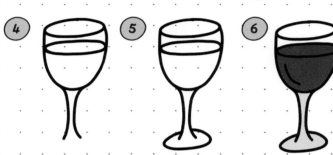

Cocktail

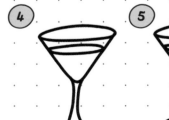
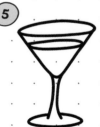
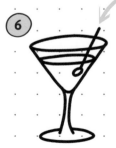

Add a semicircle to the top of the cocktail stick for a fun umbrella drink.

Desserts

Ice-Cream Cone

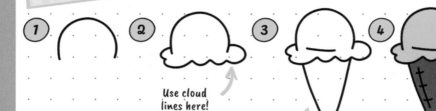

1

2

Use cloud
lines here!

For a bowl instead of a cone,
draw a wide, shallow "U"
shape instead.

3

4

ADD MORE
SCOOPS FOR A
SPECIAL TREAT.

Cake

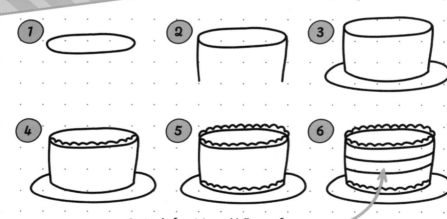

1

2

3

4

5

6

Instead of a stripe, add flowers for a
fancy cake (see page 55 for ideas).

Pie

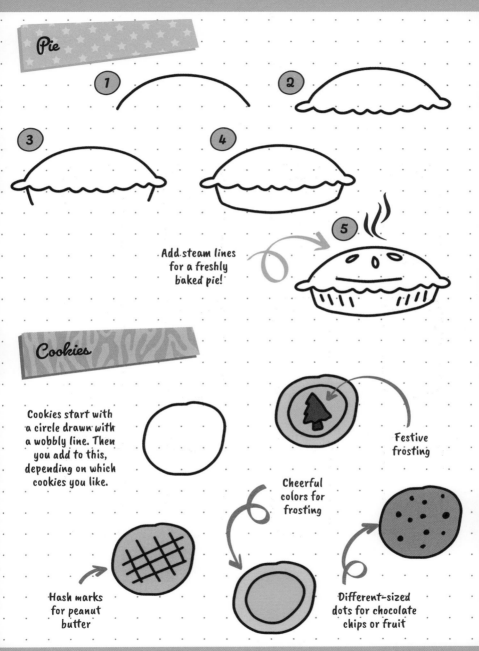

1

2

3

4

Add steam lines for a freshly baked pie!

5

Cookies

Cookies start with a circle drawn with a wobbly line. Then you add to this, depending on which cookies you like.

Festive frosting

Cheerful colors for frosting

Hash marks for peanut butter

Different-sized dots for chocolate chips or fruit

Use these cylinders to practice different drink styles...

... and these circles to try out different cookies!

CHAPTER 6

Out and About

While our lives may look very different, we are similar in that we often have errands or tasks or jobs that bring us out of the house. How do we get there? What do we do when we are there?

In this chapter, we'll be exploring some of the stuff we do (and some of the ways we get there) when we head out and about. The world is a huge place, and this is by no means an exhaustive chapter, but I hope there is enough here to help you tailor your doodles to your specific life!

Transportation

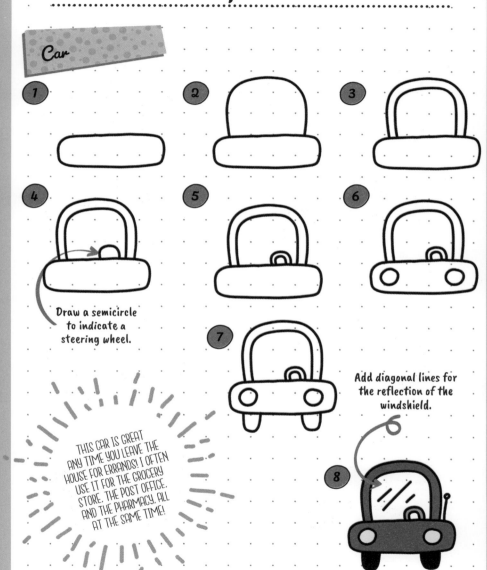

Car

1

2

3

4
Draw a semicircle to indicate a steering wheel.

5

6

7
Add diagonal lines for the reflection of the windshield.

8

THIS CAR IS GREAT ANY TIME YOU LEAVE THE HOUSE FOR ERRANDS! I OFTEN USE IT FOR THE GROCERY STORE, THE POST OFFICE, AND THE PHARMACY, ALL AT THE SAME TIME!

Truck

Bring this rectangle to the top of the doodle for a van instead.

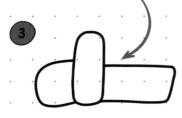

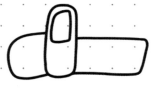

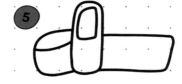

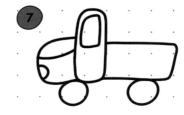

Gas Pump

This is a great spot to record how much you spend at the gas pump each trip.

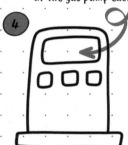

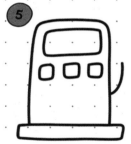

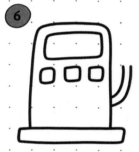

Bicycle

1

2

Make the tire much thicker for an off-road or motorized bicycle.

3

4

5

6

7

8

9

10

11

Bus

Instead of a line, you could write a destination in here.

USE YELLOW FOR A SCHOOL BUS OR USE THE COLORS OF YOUR LOCAL PUBLIC TRANSPORTATION (MINE ARE WHITE AND PURPLE).

Practice drawing different modes of transportation.

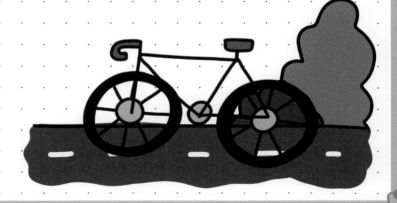

Medical

Pill

USE THESE DOODLES FOR REMINDERS OF WHEN TO TAKE YOUR MEDICINE!

Pill Bottle

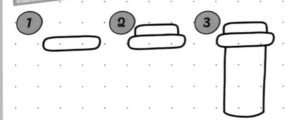

Instead of squiggly lines, write down the name of the medicine you need to refill.

Heart Rate

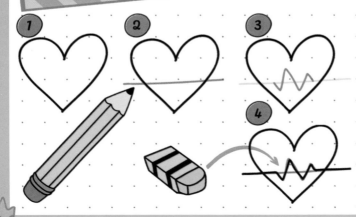

This is great for tracking blood pressure, too!

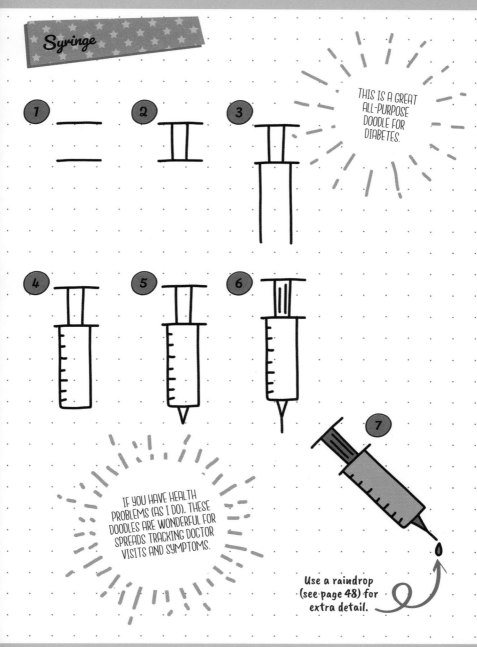

Syringe

1

2

3

THIS IS A GREAT ALL-PURPOSE DOODLE FOR DIABETES.

4

5

6

IF YOU HAVE HEALTH PROBLEMS (AS I DO), THESE DOODLES ARE WONDERFUL FOR SPREADS TRACKING DOCTOR VISITS AND SYMPTOMS.

7

Use a raindrop (see page 48) for extra detail.

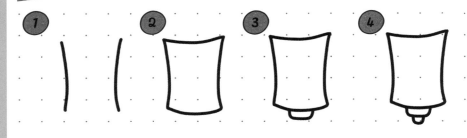

Add the tubing from steps 8–9 now if you don't want the IV stand.

Stethoscope

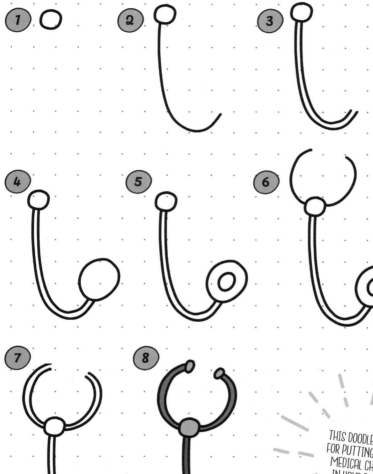

1
2
3
4
5
6
7
8

THIS DOODLE IS GREAT FOR PUTTING VARIOUS MEDICAL CHECKUPS IN YOUR PLANNER.

Tooth

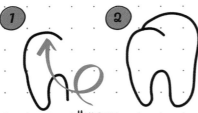

1

2

You can exaggerate this bump to make a bigger tooth.

3

4

THIS DOODLE IS GREAT FOR DENTAL APPOINTMENTS OR REMINDERS TO REPLACE YOUR TOOTHBRUSH.

Bandage

1

2

3

4

Glasses

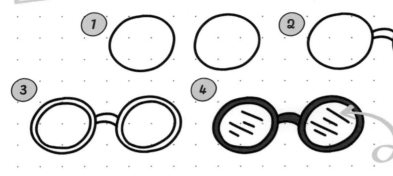

Instead of lines, write the time of your next optical appointment in the lenses!

Doctor's Bag

This doodle also works well as a handbag.

Shopping

Shopping Bags

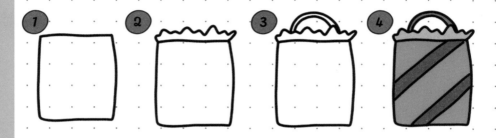

DECORATE YOUR SHOPPING BAGS BASED ON THE STORE YOU ARE GOING TO.

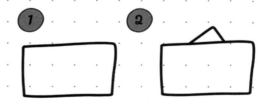

Packages

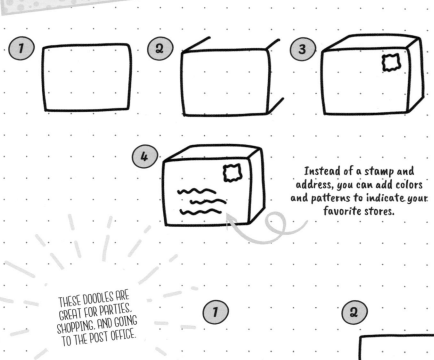

Instead of a stamp and address, you can add colors and patterns to indicate your favorite stores.

THESE DOODLES ARE GREAT FOR PARTIES, SHOPPING, AND GOING TO THE POST OFFICE.

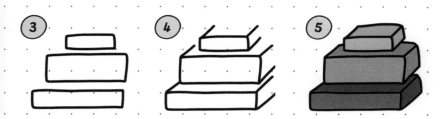

Shopping List

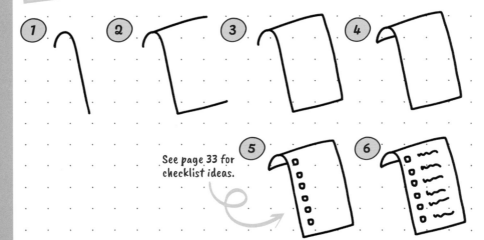

See page 33 for checklist ideas.

Shopping Cart

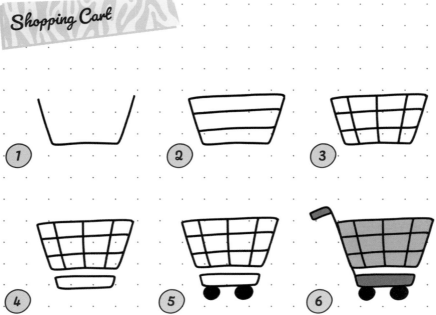

1

2

3

4

You can doodle all sorts of
foods in the top of your bag.

5

6

7

8

9

You can write what stores
you're shopping at in the
blank part of the bag!

What errands did you run this week?
This past month? Practice drawing
corresponding doodles.

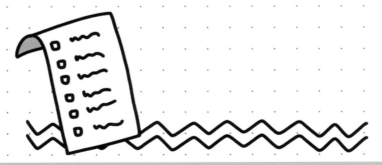

Work

Briefcase

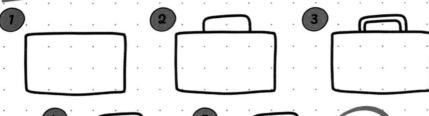

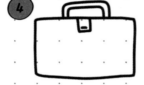

For a fun embellishment, use a metallic gold pen to fill in the buckle and corners.

Wallet

Use curved lines to close the shape.

THESE TWO DOODLES ALSO WORK WELL FOR TRAVEL PLANS.

Add some small details.

1

2

3

4

1

2

3

4

I PREFER TO USE THE
ROTARY PHONE TO
INDICATE PHONE CALLS.
I THINK IT'S CUTER.

5

6

7

8

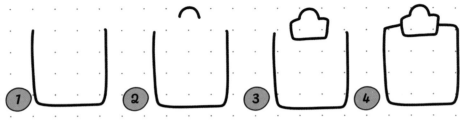

Clipboard

1
2
3
4

5

6

Replace the squiggly lines with a checklist (see page 33 for ideas)..

THIS CUTE DOODLE CAN BE USED TO INDICATE SO MANY ADMINISTRATIVE TASKS!

File

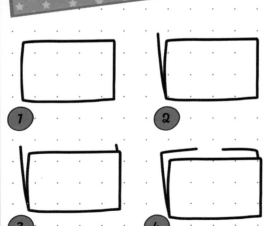

1

2

3

4

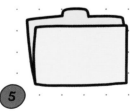

5

Computer

①

②

③

④

⑤

⑥

THIS IS PROBABLY MY MOST-USED DOODLE! IT IS MY GO-TO "WORK" DOODLE FOR PROBABLY 80 PERCENT OF MY WORK TASKS—I JUST MADE THAT STAT UP!

⑦

Work Hats

HATS CAN BE ADAPTED TO SUIT MANY DIFFERENT PROFESSIONS, SUCH AS CONSTRUCTION WORKER, FIREFIGHTER, TRAIN CONDUCTOR, POLICE OFFICER, ETC.

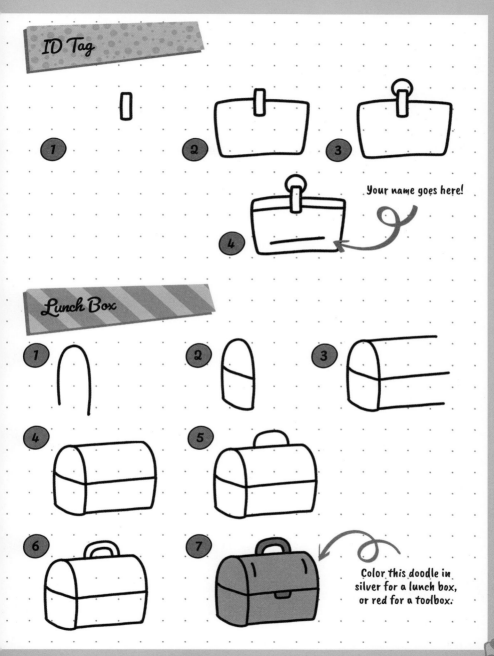

ID Tag

1

2

3

Your name goes here!

4

Lunch Box

1

2

3

4

5

6

7

Color this doodle in silver for a lunch box, or red for a toolbox.

How would you doodle phone calls you have to make? Or office tasks you might need to do?

Experiment with the work doodles
to make them fit your life!

School

Backpack

 1

 2

 3

 4

 5

Notice that this curve goes down the side of the pack.

 6

Book

 1

 2

 3

 4

 5

 6

CREATE A "BOOKS-TO-READ" PAGE USING THIS DOODLE AS A FUN BORDER.

Graduation Cap

1

2

3

4

5

6

Color the cap with your school colors!

Diploma

1

DRAW THE DIPLOMA ACROSS THE TOP OF A MEMORY-KEEPING SPREAD, WITH YOUR GRADUATION YEAR WRITTEN ON IT.

2

3

4

5

6

Eraser

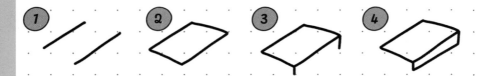

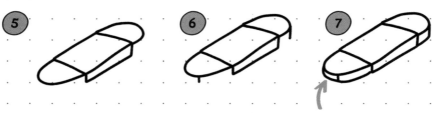

Draw little squiggles around the eraser if you want a "used" look!

Pencil

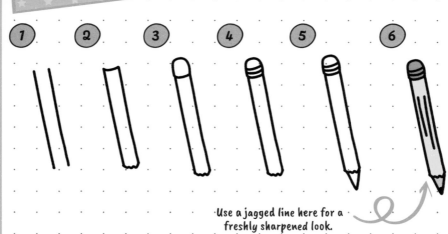

Use a jagged line here for a freshly sharpened look.

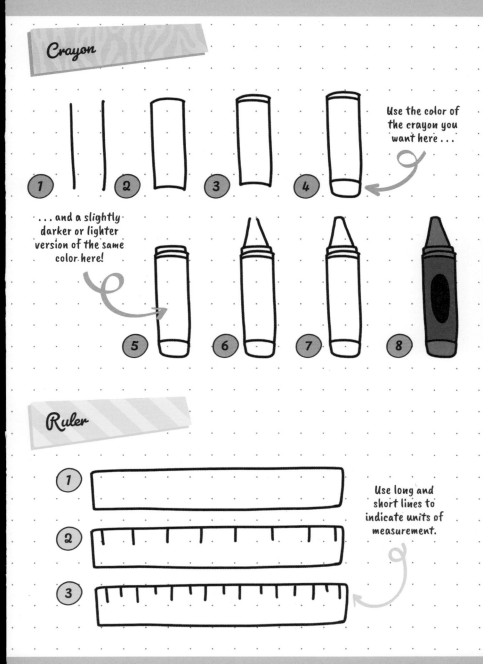

Crayon

1 2 3 4

Use the color of the crayon you want here . . .

. . . and a slightly darker or lighter version of the same color here!

5 6 7 8

Ruler

1

2

3

Use long and short lines to indicate units of measurement.

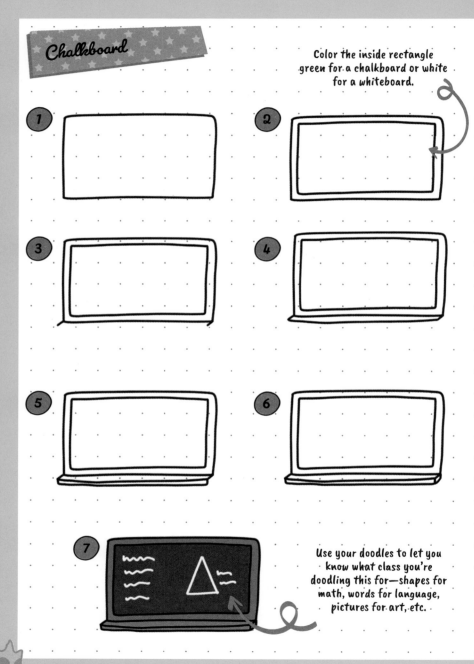

Chalkboard

Color the inside rectangle green for a chalkboard or white for a whiteboard.

1

2

3

4

5

6

7

Use your doodles to let you know what class you're doodling this for—shapes for math, words for language, pictures for art, etc.

Calculator

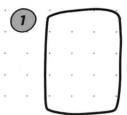 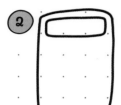 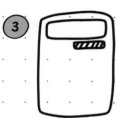

Chalk

THESE DOODLES ARE GREAT FOR STUDENTS AND TEACHERS!

Chalk Eraser

Out and About

It's recess time!
Play with the school doodles,
and have fun experimenting
and adding color.

CHAPTER 7

Fun and Fitness

We've talked about work, we've talked about chores . . .
but what about the fun stuff?

In this chapter, we cover sports, hobbies, and outdoor
fun—some of the things we probably don't plan enough
of in our lives. This is just a jumping-off point, since this
particular category is vast! If your hobby or sport of choice
isn't represented, use these doodles as practice for
doodling your own favorite pastimes.

Sports

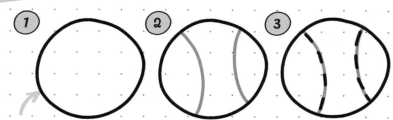

1 Many of the sports balls in this chapter start with a circle!

2

3

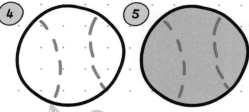

4

5 Color the ball white for a baseball, or use a colored highlighter to make it a softball.

Use a red pen for the jagged line to add extra detail.

Baseball Bat

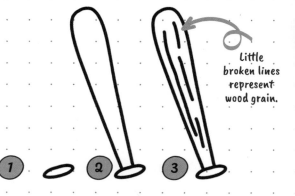

Little broken lines represent wood grain.

1 **2** **3**

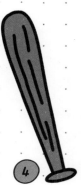

4

Basketball

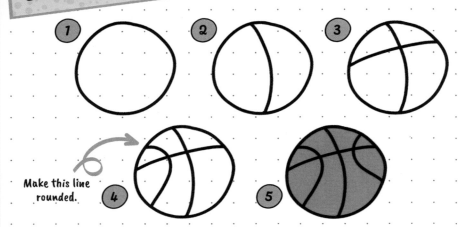

Make this line rounded.

Volleyball

Make sure to curve these lines in opposite directions.

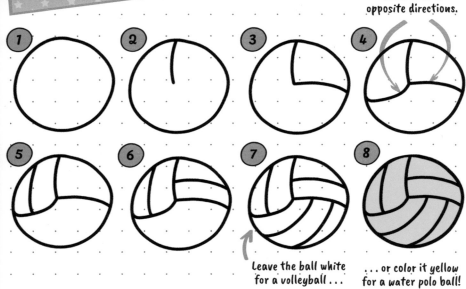

Leave the ball white for a volleyball . . .

. . . or color it yellow for a water polo ball!

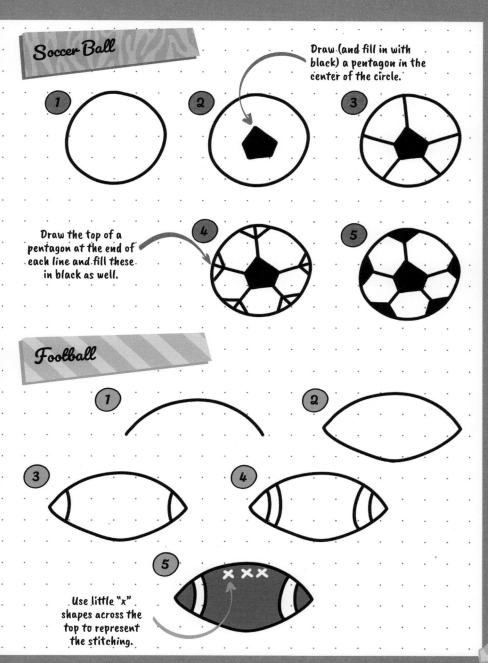

Soccer Ball

1

2 Draw (and fill in with black) a pentagon in the center of the circle.

3

4 Draw the top of a pentagon at the end of each line and fill these in black as well.

5

Football

1

2

3

4

5 Use little "x" shapes across the top to represent the stitching.

Tennis Ball

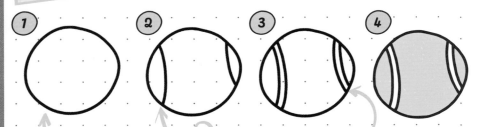

1 Tennis balls are smaller than other sports balls.

2 Use curving lines here . . .

3

4 . . . then double them.

LENGTHEN THE HANDLE TO CREATE A BADMINTON RACKET.

Tennis Racket

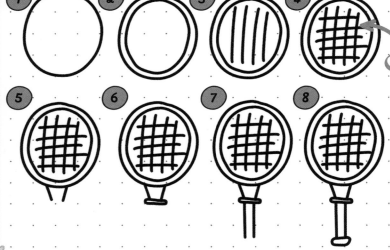

1 **2** **3** **4**

Use crosshatching to simulate the net.

5 **6** **7** **8**

Bowling Ball

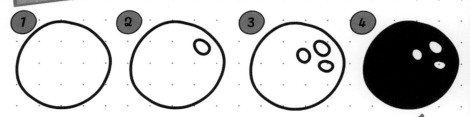

Color the ball in black (or whatever color you want your bowling ball to be).

Hockey Puck

Use gray on top and black for the side to give depth to the puck.

Hockey Stick

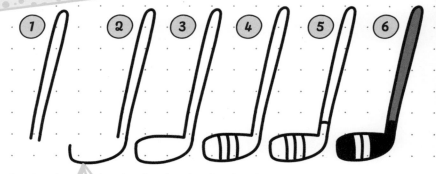

You can lengthen this section to create a great spot for writing in practice times.

Gymnastics Rings

Repeat the doodle to make a pair of rings.

Badminton Birdie

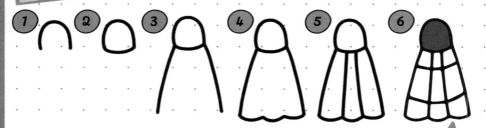

Pair this with the racket from page 198.

Table Tennis Paddle

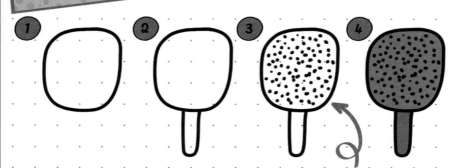

Use stippling to show the texture of the paddle.

Golf Ball

1

2

Add stippling along the bottom of the ball for shading.

Golf Club

This doodle is a slightly modified version of the hockey stick on page 199.

1

2

3

4

5

Golf Hole

1

2

3

4

5

Add a rounded shape around the hole to represent the golf green.

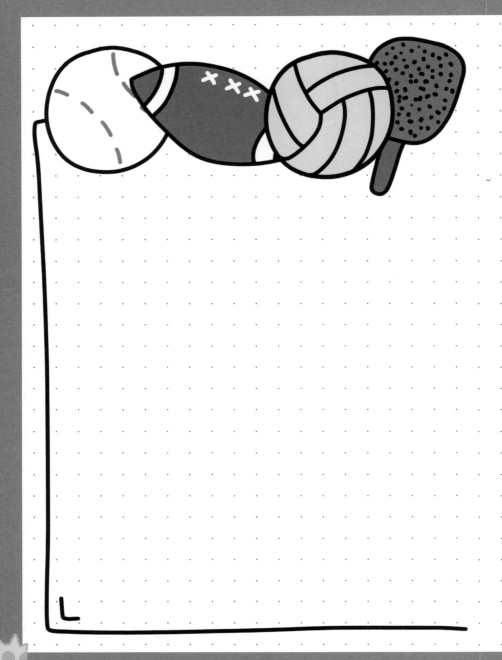

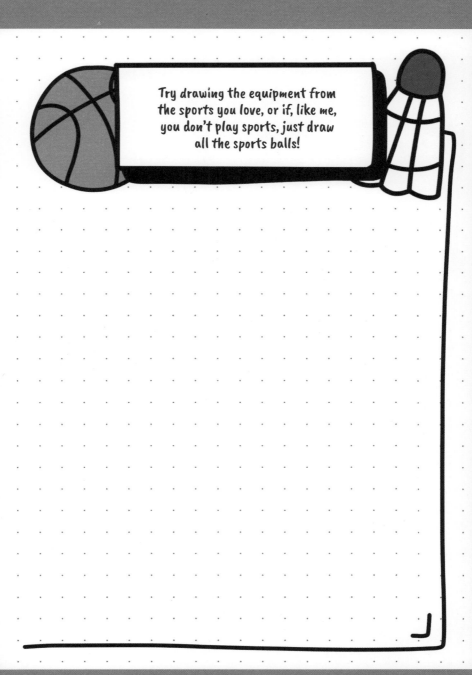

Try drawing the equipment from the sports you love, or if, like me, you don't play sports, just draw all the sports balls!

Outdoors

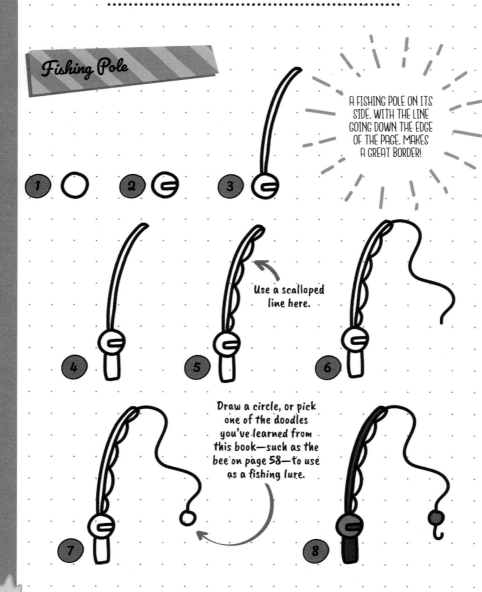

Fishing Pole

A FISHING POLE ON ITS SIDE, WITH THE LINE GOING DOWN THE EDGE OF THE PAGE, MAKES A GREAT BORDER!

1

2

3

4

5

Use a scalloped line here.

6

7

Draw a circle, or pick one of the doodles you've learned from this book—such as the bee on page 58—to use as a fishing lure.

8

Tent

1 2 3 4

5 6

ONCE YOU ARE COMFORTABLE DRAWING THIS TENT. START WITH A DIFFERENT SHAPE. SUCH AS A PENTAGON.

Draw little rectangles for tent spikes.

Binoculars

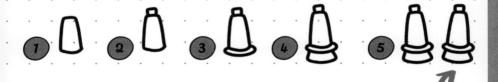

1 2 3 4 5

Repeat steps 1—4 a second time . . .

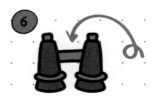

6

. . . and connect with two horizontal lines.

Ski Goggles

①

②

Draw a shallow scalloped line with two bumps under the straight line.

③

Repeat the shape inside the initial lines, then fill in with black.

④

⑤

⑥

Ski Poles

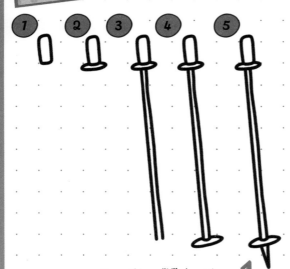

Use a skinny "V" shape to create the point of the pole.

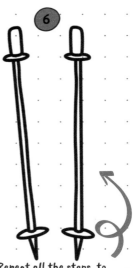

Repeat all the steps to create a pair of poles.

Surfboard

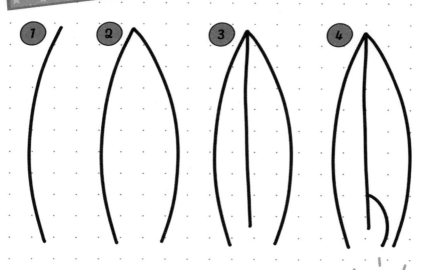

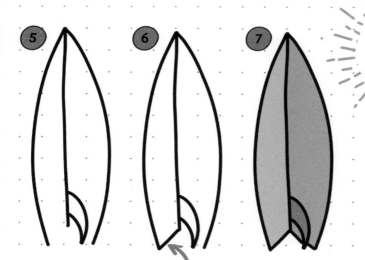

USE COLORS, DOODLES, AND PATTERNS TO DECORATE YOUR SURFBOARD.

Connect the bottom of the surfboard using diagonal lines.

Sailboat

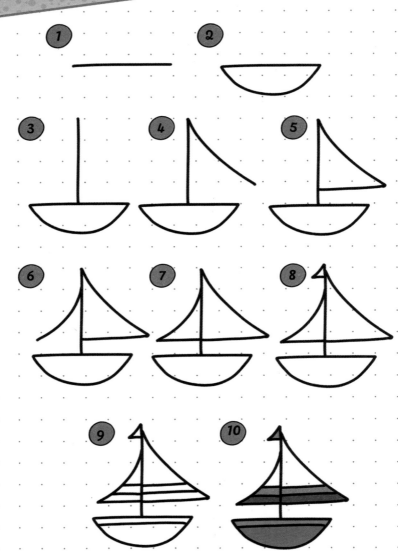

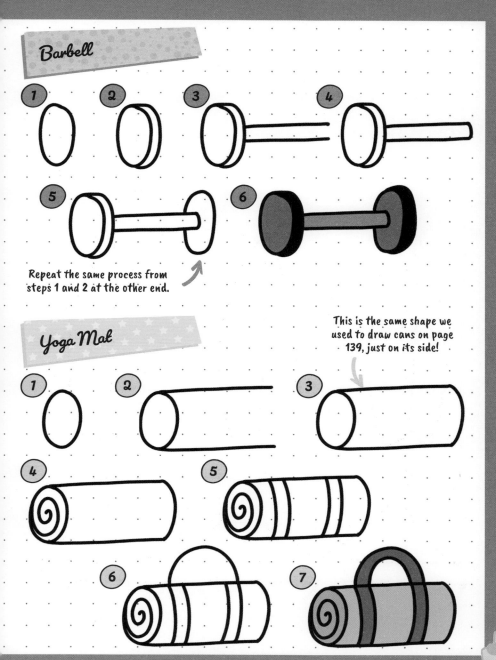

Barbell

1 **2** **3** **4**

5 **6**

Repeat the same process from steps 1 and 2 at the other end.

Yoga Mat

This is the same shape we used to draw cans on page 139, just on its side!

1 **2** **3**

4 **5**

6 **7**

Use these templates to practice drawing different patterns and decorations for fun activity doodles.

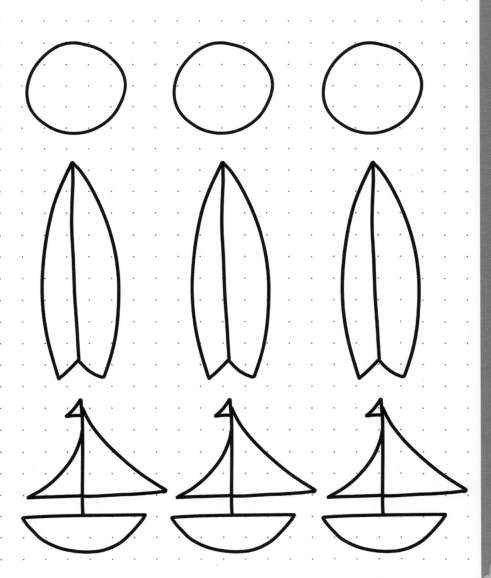

Hobbies

Paintbrush

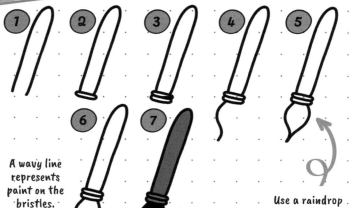

A wavy line represents paint on the bristles.

Use a raindrop shape for the bristles.

Paint Palette

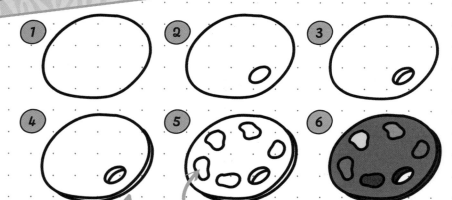

Use curved lines to create depth.

Blobby shapes around the edge indicate the paint.

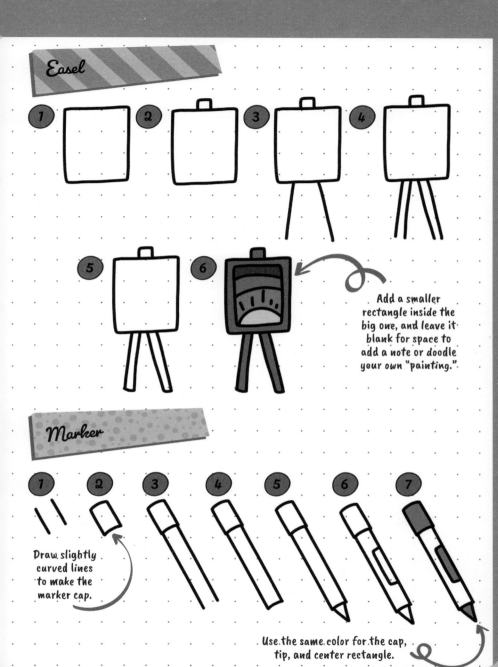

Easel

Add a smaller rectangle inside the big one, and leave it blank for space to add a note or doodle your own "painting."

Marker

Draw slightly curved lines to make the marker cap.

Use the same color for the cap, tip, and center rectangle.

Sewing Needle

Use a long, curving "V" shape to finish the needle.

Crochet Hook

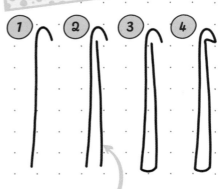

Draw this line from the bottom to just under the curve on top.

Thread

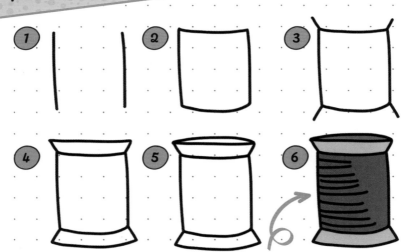

Use slightly curved hatching to represent the thread.

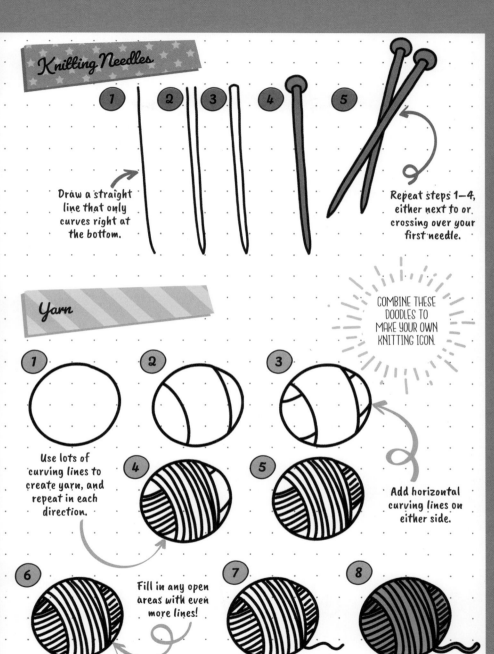

Knitting Needles

1 2 3 4 5

Draw a straight line that only curves right at the bottom.

Repeat steps 1–4, either next to or crossing over your first needle.

COMBINE THESE DOODLES TO MAKE YOUR OWN KNITTING ICON.

Yarn

1 2 3

Use lots of curving lines to create yarn, and repeat in each direction.

4 5

Add horizontal curving lines on either side.

6 7 8

Fill in any open areas with even more lines!

Music Staff

1 Draw a long, wavy horizontal line...

2 ...and repeat it four more times.

3 A basic note is a filled-in circle...

4 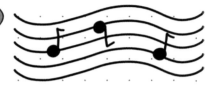 ...with a long vertical line and a short horizontal line.

Musical Symbols

 Use other musical symbols to dress up your staff.

Treble Clef

1 **2** **3**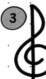

 Follow the arrows in a swirling line to create the treble clef.

 Use these extra clefs to practice the swirling line.

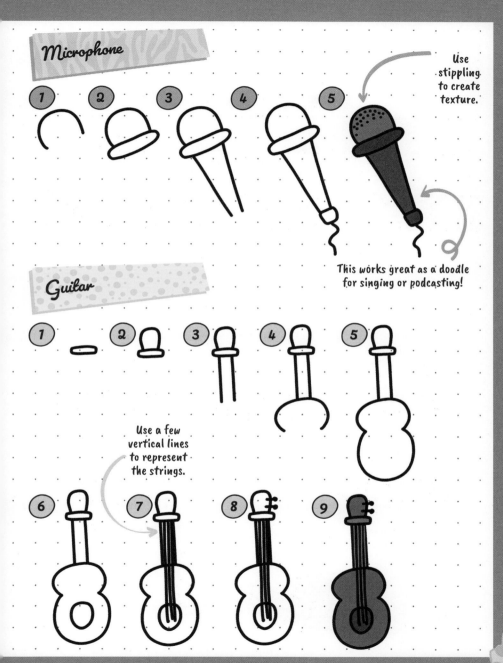

Microphone

1 2 3 4 5

Use stippling to create texture.

This works great as a doodle for singing or podcasting!

Guitar

1 2 3 4 5

Use a few vertical lines to represent the strings.

6 7 8 9

Washi Strip

Use jagged lines for a torn look.

Fill the tape in with polka dots, stripes, flowers . . . anything you want!

Washi Roll

Start here and finish the tape off.

Add a curved line for the inside of the roll.

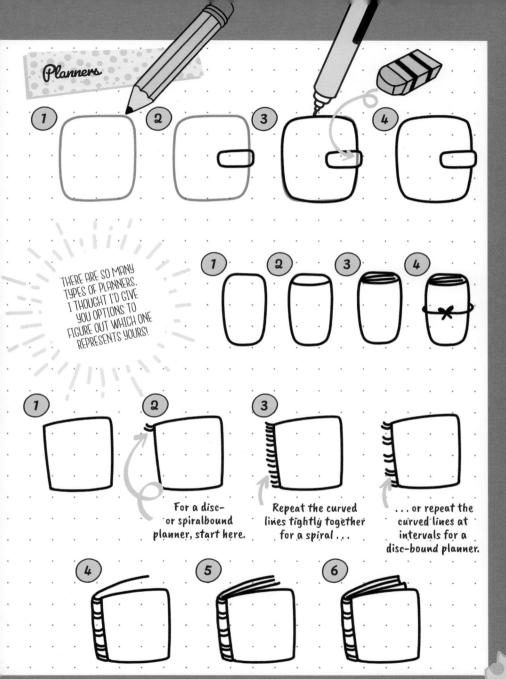

Planners

1 2 3 4

THERE ARE SO MANY TYPES OF PLANNERS, I THOUGHT I'D GIVE YOU OPTIONS TO FIGURE OUT WHICH ONE REPRESENTS YOURS!

1 2 3 4

1 2 3

For a disc- or spiralbound planner, start here.

Repeat the curved lines tightly together for a spiral . . .

. . . or repeat the curved lines at intervals for a disc-bound planner.

4 5 6

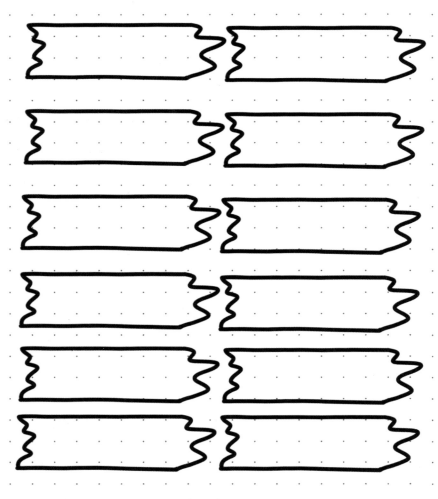

Decorate these strips with your favorite washi patterns...
or your dream washi!

Use this space to doodle your current planner, planners you've tried, or all the planners!

Self-Care

Hairbrush

Short horizontal lines and stippling create the impression of bristles.

1 2 3 4 5 6

Toothbrush

1 2 3

Use a slightly bumpy line for the bristles.

4 5 6

A wavy line finishes the toothpaste.

Comb

Use a deep, rounded, scalloped line for the teeth of the comb.

1 2 3

Hair Bow

1

2

3

4

Add a narrow curved line for a crease in the bow . . .

5

. . . and repeat multiple times. The fancier the bow, the more creases!

6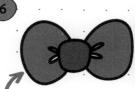

Stop here for a hair bow or continue to create a wash-day wrap!

7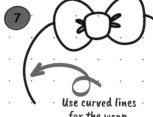

Use curved lines for the wrap.

8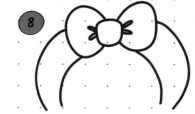

9

10

Use a "V" shape made of squiggly lines for the bottom of the wrap.

Mirror

1

2

3

Use diagonal lines to represent reflection, or doodle a self-portrait!

Bubbles

FOR BUBBLES, DRAW CIRCLES IN MULTIPLE SIZES. ADD A CURVED LINE IN THE LARGER CIRCLES FOR A REFLECTION.

Bathtub

1

2

3

4

5

Use a cloudlike, bouncy line for the bubble bath . . .

6

. . . and add bubbles for a finishing touch!

Shower

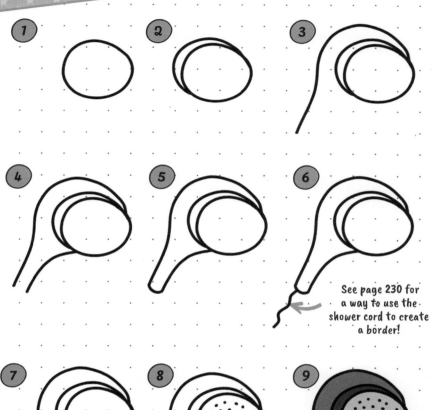

See page 230 for a way to use the shower cord to create a border!

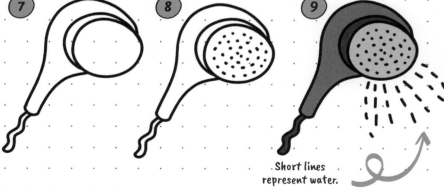

Short lines represent water.

Nail Polish

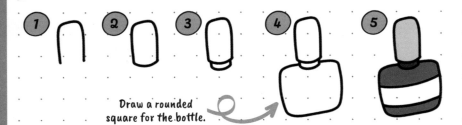

Draw a rounded square for the bottle.

Makeup Palette

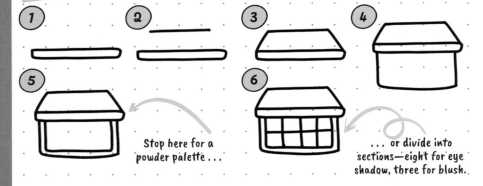

Stop here for a powder palette . . .

. . . or divide into sections—eight for eye shadow, three for blush.

Lipstick

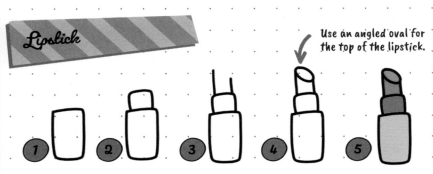

Use an angled oval for the top of the lipstick.

Makeup Brushes

① | |

② [drawing of curved cup outline]

Use a rectangle for the body of a brush . . .

③ [drawing of cup with one rectangle brush]

. . . and repeat for more brushes.

④ [drawing of cup with multiple rectangle brushes]

YOU CAN USE LONGER, NARROWER RECTANGLES FOR A CUP OF PAINTBRUSHES!

Top with different teardrops and brush-head shapes, then fill in with black.

⑤ [drawing]

⑥ [drawing]

⑦ [drawing]

⑧ [finished colored drawing]

Perfume

① [oval] ② [oval with top] ③ [bottle] ④ [bottle] ⑤ [finished colored bottle]

Start with any shape—rounded, square, diamond: look at actual perfume bottles for inspiration.

Sleeping Mask

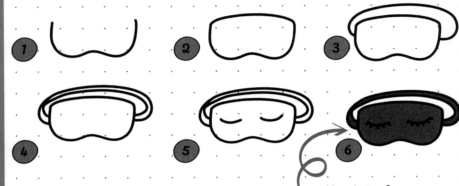

Add eyelashes for a fun touch!

Candle

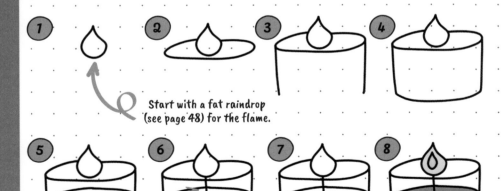

Start with a fat raindrop (see page 48) for the flame.

Draw a straight line into the center of the candle for the wick.

Incense

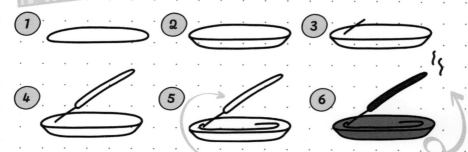

1 **2** **3**

4 **5** Use a long, skinny oval for the body of the incense. **6** Use squiggly lines for smoke.

Bed

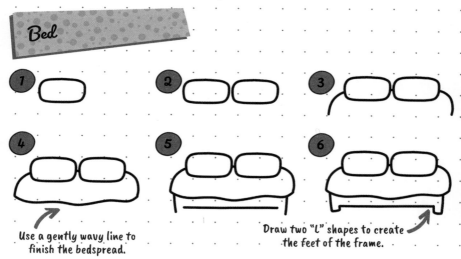

1 **2** **3**

4 Use a gently wavy line to finish the bedspread. **5** **6** Draw two "L" shapes to create the feet of the frame.

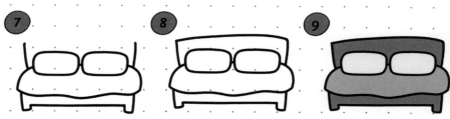

7 **8** **9**

Use the self-care doodles to draw your ideal day of relaxation and pampering!

CHAPTER 8

Now What?

Phew! You just finished an entire book of doodling.
I hope you feel proud of yourself!

I also imagine you are wondering what to do next. Well, never
fear, I've got some great ideas to help you continue doodling,
practicing, and expanding your doodle catalog!

Use this space to brainstorm other doodles you'd like to figure out. Hobbies I didn't cover? Food items or sports that you're interested in? This page can be your ongoing list of new doodles to try!

Making Stickers

Once you've started making doodles, a fun way to use them in your planner is to make stickers out of them. While there are ways to use cutting machines—such as Cricut or Silhouette—to make your own stickers, all you need is sticker paper and a pair of scissors. You can find sticker paper at most office-supply stores. Look for "full sheet labels."

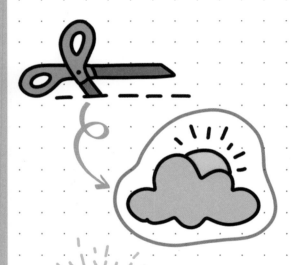

1. First, decide what doodles you want to use as stickers, then either draw them directly onto the sticker paper or on regular paper that you can scan into your computer later.

2. Add a light line around the sticker. Leave a little space between the doodle and the line, and soften any curves. The less detail in this line, the better.

3. This line is your cutting guide. Use a pair of sharp scissors to cut along the line.

4. Repeat for all of your doodles! Now you have homemade stickers.

THIS METHOD OF CUTTING AROUND A DRAWING IS CALLED "KISS CUTTING."

game

Try adding lines next to or under your doodle to write in appointment times or names.

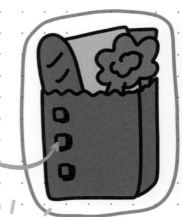

Use your doodle as a checklist—I use grocery bags to list which stores I am going to on my shopping day!

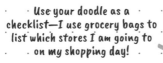

THERE IS NO LIMIT TO HOW YOU CAN USE DOODLES IN YOUR PLANNER. ANY TIME YOU HAVE ONE THAT WORKS PARTICULARLY WELL. MAKE A NOTE TO TURN IT INTO A STICKER LATER!

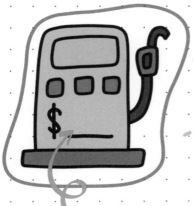

Use a blank area on a doodle to record money or time spent (or anything else).

If you have doodles you like to use all the time, consider drawing them with their cut lines and scanning them into your computer. Then use a color printer to print them onto sticker paper. This works well for weather doodles and appointment doodles you use most often.

Planner Practice

Use this space to practice planning a week out in your planner! What doodles would you use? How would you use them? You got this!

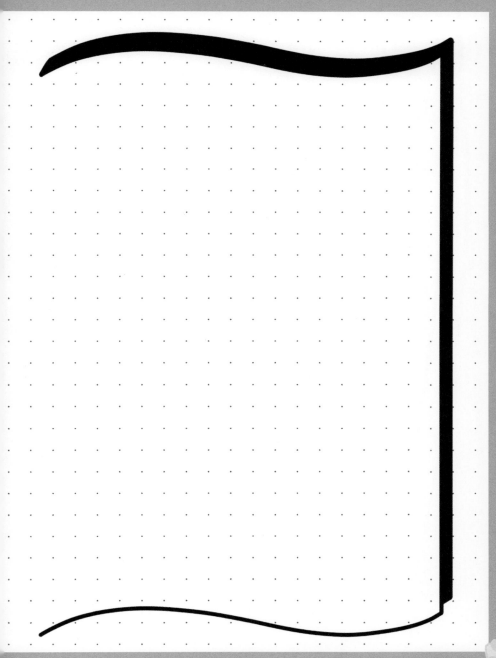

YOU DID IT!

Next Steps

- [] If you haven't already, begin a daily doodling practice. Ten minutes each day.

- [] You can find me online at **www.cindyguentertbaldo.com** for monthly doodling challenges to help with prompts.

- [] Challenge yourself to use doodles every week in your planning/journaling practice. Start with one per day and build from there.

- [] Start gifting your doodles to friends and family. Nothing helps your confidence more than impressing someone who has never tried doodling before!

Give yourself a rosette and a pat on the back.
Here is one to cut out and keep in your journal.

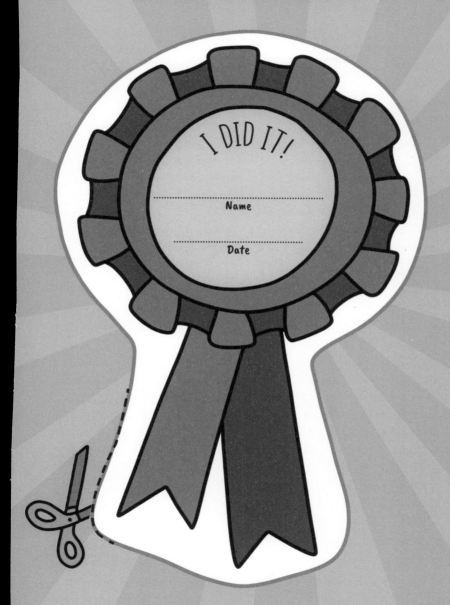

I DID IT!

Name

Date

Acknowledgments

If you had told me when I was in high school that I'd not only write a book, but go on to write a second one, I would have laughed in your face. I expected to live the life of a single scientist working in a genetics lab. That's not exactly how it went.

I don't know where I'd be without my family: my husband and best friend Jesse, who constantly tells me how awesome I am even when I don't believe him; my kids, Kat and RJ, who continually show me how vibrant and hilarious they are; my sisters, Amy and Becca, who only sometimes make fun of me, but often listen when I'm having a rough time; my uncle Rich, who has filled the role my parents might have had they still been alive; and all of the rest of my family for being the most loving and caring people I could possibly know.

Thanks once again to Kate Kirby, Claire Waite Brown, and the rest of the Quarto team for helping me realize yet another book in a bright and fun fashion; to Kristin Damian, who, despite having a rough 2020, has been a supportive friend and business associate (and a constant source of inspiration); to Jeanette Richardson and the Wild for Planners crew for always believing in me.

To the CGB community, the ones who hang out in the livestreams and the ones who answer questions in the Facebook group, the people who can recognize my cats by their meows and the ones who find realistic inspiration to share when we are feeling down, those who comment on my videos and those who have never commented, those who bought the last book and found it on Amazon before I even knew it was there (and those who did that again for THIS book!), you make every day fun, exciting, and new for me . . . and I love you for it.

And, finally, to my patrons. You make everything I do actually possible. Those of you who hang out with me every week and help lift my spirits when times are hard, and those of you who have supported me for a month, for a year, since the beginning, you are the reason I do what I do. I love you all.